Treasures of the Abraham Lincoln Presidential Library

Treasures of the Abraham Lincoln Presidential Library

Edited by Glenna R. Schroeder-Lein

Illinois Historic Preservation Agency and
Southern Illinois University Press / Carbondale

Copyright © 2014 by State of Illinois, Historic Preservation Agency
Printed in the United States of America

17 16 15 14 4 3 2 1

Book design by Linda Jorgensen Buhman
Front cover design by Mary Rohrer

Library of Congress Cataloging-in-Publication Data
Treasures of the Abraham Lincoln Presidential Library / edited by Glenna R.
Schroeder-Lein.
 pages cm
Includes index.

ISBN 978-0-8093-3335-6 (cloth) ISBN 0-8093-3335-X (cloth)
ISBN 978-0-8093-3336-3 (paperback) ISBN 0-8093-3336-8 (paperback)
ISBN 978-0-8093-3337-0 (e-book) ISBN 0-8093-3337-6 (e-book)

1. Abraham Lincoln Presidential Library and Museum—Catalogs. 2. Lincoln,
Abraham, 1809–1865—Museums—Illinois—Springfield. 3. Presidential libraries—
Illinois—Springfield. I. Schroeder-Lein, Glenna R., 1951– , editor.
E457.65.T74 2014
026'.97370977356—dc23 2013041620

The paper used in this publication meets the minimum requirements of American
National Standard for Information Sciences—Permanence of Paper for Printed
Library Materials, ANSI Z39.48-1992. ∞

Front cover and frontispiece illustrations (left to right): letter to Governor Henry Horner on
thin sheet of copper; *Pigs Is Pigs*, a miniature book published by Ward Schori of Evanston,
Illinois; Everett copy of Abraham Lincoln's Gettysburg Address; ambrotype of John Hay
at about age sixteen; *Vicksburg Citizen* newspaper printed on wallpaper; and boots worn
by gubernatorial candidate Dan Walker during his 1971 walk through Illinois.

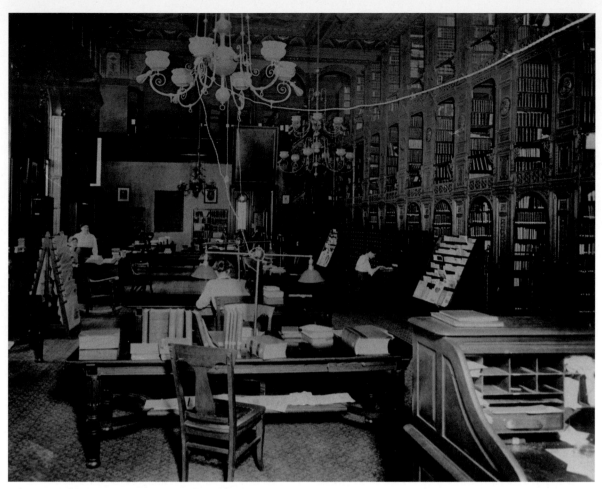

Library reading room in Centennial Building, 1920s

A Treasure of the Abraham Lincoln Presidential Library may be

something unique or near-unique to the Library

something with an especially interesting historical context

something with a particular visual interest

something unexpected in Library holdings

something extremely useful to researchers

something representative of a larger collection, that as a whole is special and useful

something particularly prized

A Treasure may be something already famous or something still obscure.

Contents

Foreword

"Fellow-citizens, *we* cannot escape history. We of this Congress and this administration, will be remembered in spite of ourselves. No personal significance, or insignificance, can spare one or another of us. The fiery trial through which we pass, will light us down, in honor or dishonor, to the latest generation. . . . The way is plain, peaceful, generous, just—a way which, if followed, the world will forever applaud, and God must forever bless" (Abraham Lincoln, Annual Message to Congress, December 1, 1862).

President Abraham Lincoln was referring to the struggle between North and South, between slavery and freedom. These are some of the most famous words by one of the world's most recognized and respected leaders. But history is also made by those who are not in history books—the workers, teachers, immigrants, pioneers, and soldiers of all ethnicities who lived and died, and left us pieces of their lives to inform and inspire us.

I am pleased to offer you *Treasures of the Abraham Lincoln Presidential Library*, a book celebrating a few of the stories of both the famous and the obscure contained in the thirteen million plus items the Library has acquired since its inception in 1889. This 125th anniversary volume will highlight and inform you about the wonderful resources available in the Library that concern all aspects, eras, and personalities of the Prairie State's history.

Each department of the library has selected what staff members consider to be "treasures" and has written a brief essay about each item—its provenance, if known; how it might have been used for research purposes; and its connection to other items in the Library's collections. More than seventy-five items from the Published Works, Manuscripts, Audio Visual, Newspapers on Microfilm, and Abraham Lincoln collections are featured in this beautifully illustrated publication.

In addition, we have asked selected users to write how they have used the Library's collections and the value and rewards they have received from their research. These users include authors, scholars, historians, archivists, genealogists, educators, and others who have benefitted from the Library's vast storehouse of historical knowledge.

We hope this book opens your eyes to the seemingly endless treasure trove of stories contained within the Abraham Lincoln Presidential Library. We trust your journey of discovery of this world-class resource will awaken a lifelong desire to learn and experience our shared heritage.

Pat Quinn
Governor
State of Illinois

Preface

A distinguished Lincoln scholar, Harry E. Pratt, once called the Illinois State Historical Library "the fun house," for that is where he spent endless enjoyable hours plowing through books, articles, newspapers, photos, prints, and manuscripts, aided by an unfailingly friendly, helpful staff. That has been my experience both there and at the Abraham Lincoln Presidential Library, which now houses the Illinois State Historical Library's collections. They were previously located in the Old State Capitol's lower level.

The Abraham Lincoln Presidential Library offers under one roof a cornucopia of valuable research materials, easily accessible to scholars and students. Years ago, when plans for that Library were being drafted, I was asked if it would be desirable to have the Lincoln Collection moved to the new facility and the other collections—manuscripts, newspapers, books, prints, and photos—retained at the Old State Capitol. I emphatically urged that all collections be housed in the new Library.

Having spent many months conducting research in the old Library, I knew how handy it was to have all the various departments in close proximity. In the windowless basement of the Old State Capitol, the manuscripts room was immediately adjacent to the main reading room, and the microfilm room (home to the vast newspaper archive) was just down the hall. While poring over manuscripts, if I found something puzzling, I could rise from my chair, walk a few paces, and consult the large reference collection in the next room or request books and journals that would shed light on the matter. Or I could proceed a few steps further and easily reach the newspaper collection with its endless reels of microfilm and valuable indexes.

Another repository where I spent a great deal of time was not so user-friendly. The manuscript division was in one building, far from the newspaper room, and the main book collection was in another building entirely, along with the prints and photos division. To move back and forth among those different locales was inconvenient, to say the least.

At the new Library, the invaluable manuscript collections, providing essential raw material for historians, are lovingly tended and made easily

available. Like the manuscript room, the nearby microfilm, photo, and main reading rooms are staffed by helpful, knowledgeable, and efficient librarians. Over the years I have been the beneficiary of much-appreciated assistance from them in all departments. I am reluctant to single out specific individuals, lest I inadvertently omit some that belong on that list. They are as much treasures of the Library as the books, newspapers, manuscripts, prints, and photographs there.

The comfortable, up-to-date facilities, along with the exceptionally helpful staff, make the Abraham Lincoln Presidential Library an ideal place for students, historians, and genealogists to conduct historical research.

Michael Burlingame
Chancellor Naomi B. Lynn Distinguished Chair in Lincoln Studies
University of Illinois, Springfield

Introduction

All the collections at the Abraham Lincoln Presidential Library are treasures—some much heralded, others known to a few. Many of us who are Library "regulars" have our own favorite collections and stories to accompany them.

Originally named the Illinois State Historical Library, the institution is now celebrating its first 125 years. The curatorial staff has chosen some particularly interesting treasures for you to enjoy. I suspect their choices will inspire debate and stir memories, producing many personal "Treasures of the Library" books in the minds of our readers.

More than eight thousand Boys in Blue served in Illinois' Civil War regiments. Lovingly conserved photos show us young, handsome men with caps placed so jauntily on their heads. They pour their hearts out to us today. We feel war's shocking pain and its tedium through their writings.

Treasured collections of papers and photos reveal the inner thoughts of our political leaders during stressful times—the Great Depression of the 1930s or the civil disorders of the 1960s. I love the adoring wedding portraits of the Stevensons—Adlai III and Nancy especially.

The ordinary activities of government staff at work on education, transportation, revenue, or public aid open up our minds to issues of deep concern today. What can we learn from Governor Ogilvie's founding director of the Illinois Bureau of the Budget or from Governor Shapiro's mental health commission?

Of all these treasured collections, I must single out the librarians, who serve the public faithfully. Whether an internationally famous scholar or a fifth-grade boy who wants to know more about soldiers, every visitor is accorded sensitive care and the finest service. These librarians believe that nothing less is the standard for our grand state of Illinois, which stands at the heart of America.

Hip Hip Hooray for the next 125 years!

Eileen R. Mackevich
Executive Director
Abraham Lincoln Presidential Library and Museum

A Word about the Book

In celebration of the Library's 125th anniversary, members of each Library department selected the treasures for this book. In many cases it was as difficult as choosing a favorite child because the Library has so many great things. We tried to pick different types of treasures to show the wide variety of our holdings.

Each treasure is illustrated with an image, occasionally by more than one to give added perspective. Handwritten or otherwise difficult-to-read treasures include transcriptions that preserve the spelling, punctuation, and usage of the original manuscripts. The story of each treasure is briefly described, explained, or set in context as necessary, sometimes with supporting illustrations. Treasure captions include the dimensions of the original item, while supporting material does not. All treasures and supporting materials come from the Library's collections.

Periodically we have included comments from Library users about their research experience and the materials they found related to their projects.

Although we do introduce the Library and its departments, the treasures are arranged roughly by topic. These topics were determined after the treasures were chosen. Feel free to enjoy the treasures in any order you desire.

Glenna R. Schroeder-Lein

Treasures of the Abraham Lincoln Presidential Library

Part One. Background

1. *Library Historical Overview*

Four Homes for the Library

On its way to its quasquicentennial, the Illinois State Historical Library has had four homes. The first and most modest was a room or two in the present State Capitol, which had been completed shortly before 1889, when the legislature created the Library itself. The Library's second home was in the Centennial Building, the cornerstone of which was laid in 1918, marking the one-hundredth year of Illinois statehood. (It was renamed for Secretary of State Michael J. Howlett in 1992.)

When I grew up in Springfield, I remember being taken in tow to the Illinois State Library in the Centennial Building. At the east end of the third floor, beyond the State Library, was the Historical Library, but that was terra incognita for a young kid.

In 1970 the Historical Library moved a third time, to the Old State Capitol as reconstructed on Springfield's square. That handsome Greek Revival structure, to which the state offices had moved from Vandalia in 1839, served as the Sangamon County Courthouse after the state government itself moved to the present Capitol. Through a sequence of changes in the 1960s, Sangamon County built a new courthouse nearby, the old Capitol was given its original appearance above ground, and the space below ground was taken by the Historical Library, surrounded by two levels for parking.

When a decade later I returned to Illinois (and became an Illinois historian of sorts), I began using the resources of the Historical Library, as I have done ever since, always with the assistance of a capable staff. Every research foray has been enlivened by conversations with friends.

Plans for a new, fourth home for the Historical Library emerged, in a rather fitful way, in the 1980s and 1990s, at the same time that its quarters below the Old State Capitol became increasingly crowded and unserviceable. The new home came about through a combination of federal, state, city, and private contributions, both direct and indirect. In 2004, the Historical Library moved to an attractive new building a block from the Old State Capitol and was renamed the Abraham Lincoln Presidential Library. The Abraham Lincoln Presidential Museum, paired with the new Library and across the street from it, was opened in 2005. Organizationally, both Library and Museum are a part of the Illinois Historic Preservation Agency, which was formed in 1985 when the Illinois legislature combined the Historical Library with units responsible for the state's historic sites and its historic preservation program.

A few years ago, as I sat in a Lincoln bicentennial meeting in the Library's rotunda at the corner of Sixth and Jefferson, I could not but marvel at the recent transformation of that part of downtown Springfield. To my front was the remarkably successful Museum, taking the place of the city's run-down police and fire stations. To my left was an open park, not a group of non-descript business blocks. And beyond it the old, derelict Illinois Central railroad station had been renovated into a visitor center and capped by a rebuilt tower, as tall and as striking as the original one. The new Library and the new Museum, park, and visitor center, constitute a spacious and glorious reincarnation of the Illinois State Historical Library as it reaches its 125th year.

John Hoffmann
Illinois History and Lincoln Collections
University of Illinois Library, Urbana-Champaign

Chronology

1877

May 25 Illinois General Assembly establishes Illinois State Historical Library and Natural History Museum. Curator Amos H. Worthen, former state geologist, is only interested in museum and ignores library.

1889

May 25 Gov. Joseph Fifer signs bill establishing Illinois State Historical Library (ISHL).

November 25 Library formally organized with three-man board of trustees who appoint Josephine P. Cleveland first librarian at salary of $500 per year. Library's location is on third floor of west wing of (new) Capitol.

1890 Library board of trustees publishes first biennial report.

September 9 Illinois State Library gives 442 books to Library to begin its collection.

1893 Library trustees urge establishment of a state historical society.

1897

June 9 Act approved permitting counties to send their records of historical value to Library.

1898

January 1 **Jessie Palmer Weber** becomes librarian.

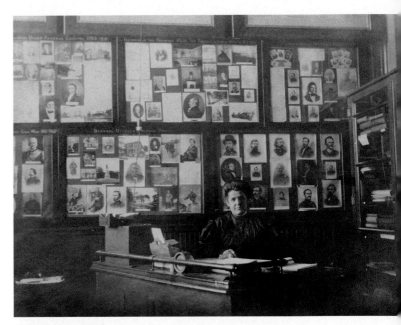

Jessie Palmer Weber

Jessie Palmer Weber (1861–1926) was the daughter of Illinois governor and U.S. senator John McAuley Palmer and the wife of Norval W. Weber. After serving as secretary to her father while he was senator, she became librarian of the Illinois State Historical Library on January 1, 1898, and served until her death. She was both a founder and a director of the Illinois State Historical Society and edited virtually all the journals and other publications of the Library and the Society during this period. She was extremely active in gathering historical material for the Library, frequently writing to those who might have useful information. Many of those letters can still be found in Library accession files and various collections.

Shortly after the Library was organized in 1889, Library trustees urged the establishment of a historical society to support the Library, but the **Illinois State Historical Society** was not founded until May 19, 1899. Four years later, the Society became a department of the Library by legislative act. For many years members of the Society paid nominal annual dues, for which they received the publications of both the Society and the Library. Sometimes these dues were also used to purchase rare manuscripts for the Library. Library employees performed editorial and clerical functions for the Society, and Library funds paid for postage and printing of all publications. Librarians functioned as Society secretary-treasurers for a time, and eventually the state historian (until 1993) was also the Society executive director. The Society, a nonprofit organization, became independent of the Library in the 1990s.

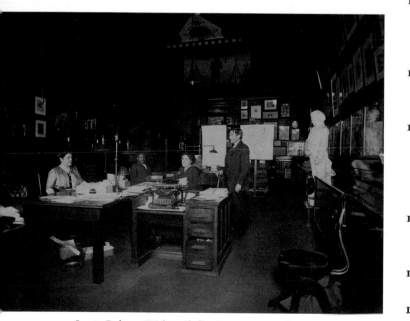

Jessie Palmer Weber (*left*), Georgia L. Osborne, and unidentified staff members in Library, 1917

1899	Library begins *Publications of the Illinois State Historical Library*.
May 19	**Illinois State Historical Society** founded.
1903	Jessie Palmer Weber becomes secretary-treasurer of Society as well as librarian.
	Library and Society publish first volume of *Illinois Historical Collections*.
	Library moves across (new) Capitol to east wing because it needs more space.
May 16	Gov. Richard Yates II signs bill making Historical Society a subsidiary department of Library.
1904	Library prepares exhibit that is shown at St. Louis World's Fair and adapted for other later fairs.
	Agreement made with newspaper publishers to exchange subscriptions for historical publications.
1905	General Assembly votes more funds for Library for publishing and for purchases of documents and other material.
1907	*Publications* title changed to *Transactions of the Illinois State Historical Society*.
1908	*Journal of the Illinois State Historical Society* begins publication as journal of both Library and Society.
July	Library expands into additional room in Capitol.
1923	Library moves to third floor of new Centennial Building to meet need for more space.
1926	Georgia L. Osborne succeeds Jessie Palmer Weber as librarian.
1930	Library board of trustees publishes its twenty-first and last biennial report.

1932

March 1 — Paul M. Angle becomes librarian.

1940 — Gov. Henry Horner bequeaths collection of published Lincoln material to Library.

1943 — Title of Library head changed from librarian to state historian.

1944 — Schoolchildren and Marshall Field III purchase Everett copy of Gettysburg Address for $60,000 and give it to Library.

1946

January 4 — Jay (James) Monaghan becomes state historian.

November 30 — *Illinois Junior Historian*, a magazine by and for junior high school students, begins publication.

1947 — Student historian education program for junior high and high school students begins.

1948 — Collector Alfred W. Stern begins donating more than 10,000 Civil War books, including many regimental histories, to Library.

1949 — Several special publications issued to commemorate Society's 50th anniversary. First student historian awards day (now Illinois History Expo).

1950

December 1 — Harry E. Pratt becomes state historian and executive director of Society.

1952

February — Special committee raises $76,076 and purchases Lincoln letters to Joshua Speed and other manuscripts for Library at auction of Oliver R. Barrett collection.

July 30 — Ronald D. Rietveld, age 14, discovers photo of Lincoln in coffin in Nicolay-Hay Papers.

On April 8, 1913, ISHL librarian Jessie Palmer Weber wrote to William L. Sullivan, secretary to Governor Edward F. Dunne, reporting serious conditions in the Library. She ended her missive:

"The Illinois State Historical Library has for several years been crowded, seemingly to its capacity for expansion, in every branch of its work. When from the fact that our floors were too heavily loaded we were obliged to give up nearly half of our shelving room, it was a severe blow and a heavy handicap.

"We need at least to devise immediately some plan whereby we may add to our newspaper shelving, and thus make room for other departments of our work.

"We need a work room and we need an assembly room, which could also be an exhibition room;

"And we need at least one reference room.

"These needs are pressing. We would gladly show the Governor our overcrowded condition and I think we would convince him that we need immediate relief."

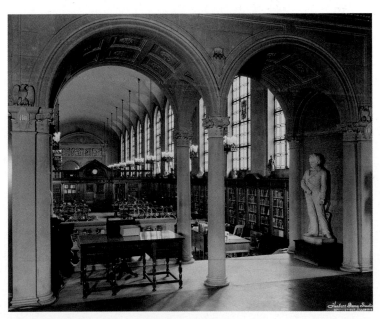

Library reading room, 1938

1954	State representative (later U.S. Senator) Paul Simon researches at Library for his book *Lincoln's Preparation for Greatness.*
1956	
September 1	Clyde C. Walton becomes state historian and Society executive director.
1957	
January	*Illinois Junior Historian* enlarged and reformatted as *Illinois History: A Magazine for Young People.*
1958	
February 1	James T. Hickey becomes first Lincoln curator.
May	First issue of Library/Society quarterly newsletter *Dispatch* published.
1959	General Assembly makes first appropriations for microfilming Illinois newspapers.
July	Library has staff of 17 and is overcrowded.
1960	
August 15	Traveling Historymobile debuts at state fair.
1961	
February 11	David Davis Mansion in Bloomington opens as historic house museum adjunct of Library and Society.
July 29	Library and Society inaugurate oral history program.
August 24	Gov. Otto Kerner signs bill for state to purchase Sangamon County Courthouse (Old State Capitol).
1962	
Summer	Robert L. Brubaker becomes first manuscripts librarian.
1963	Final volume of *Transactions of the Illinois State Historical Society* published.

In 1964–1965, during the latter part of the Civil War centennial, the Manuscripts Department received 48 Civil War collections, which contained 350 letters, 13 diaries, 5 memoirs, 2 sketchbooks, and 44 other documents.

1964–1965	Illinois Pavilion at New York World's Fair exhibits Library material including Gettysburg Address and 40 other Lincoln documents.
1965	
April 30– May 4	Library and Society help to host final conference of Civil War Centennial in Springfield.
1966	
February 7	Dismantling of Old State Capitol begins.
1967	Herbert W. Georg collection of glass negatives of Springfield (1890s–1920s) given to Library.
July 1	William K. Alderfer becomes state historian.
1969	
February 18	Library/Society gets new Historymobile replacing one that had traveled 175,000 miles and had hosted more than 1 million visitors.
November 15	Reconstructed historic section of Old State Capitol opens to public.
1970	
March– September 3	New Library facilities in Old State Capitol used for Constitutional Convention meetings.
Spring	Library gets federal grant to process and microfilm Pierre Menard collection of early Illinois manuscripts.
June 24	Library/Society receives gift of Carl Sandburg Birthplace in Galesburg.
August 8– October 6	Library moves to reconstructed **Old State Capitol**. Holdings estimated at 140,000 bound volumes, 2,785,000 manuscripts, 37,000 reels microfilm, and 1,271 Lincoln documents.
September 9	Library opens in new facilities while still moving materials.

Movers using horse trailer to take Library materials from Centennial Building to Old State Capitol (*at left*), 1970

Many changes had been made to the **Old State Capitol** during its service as the Sangamon County Courthouse. The State of Illinois wanted to restore the building to its 1858 appearance while providing a more spacious home for the Library. Beginning February 7, 1966, the Old State Capitol was dismantled, with each stone marked and stored at the State Fairgrounds. Five levels of Library stacks and three other floors of office space, surrounded by a two-level parking garage, were constructed underground, with the Old State Capitol reconstructed on top of the new Library facilities. Moving the materials from the Centennial Building to the new Library from August to October 1970 was more challenging than anticipated since the seven-foot clearance and narrow garage entrance prevented use of a moving van. Ingenious movers ultimately used a pickup truck towing a horse trailer for all except the largest materials. Some file cabinets and safes had to be brought by moving van, unloaded on the street, and rolled down the ramp into the garage before they could be brought into the building.

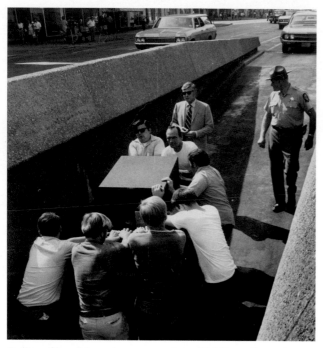

Rolling file cabinet down ramp into Old State Capitol parking garage, 1970

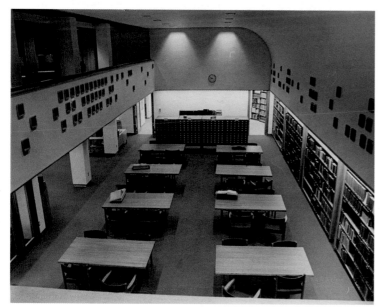

Old State Capitol reading room, 1970

1970—*continued*

October 31	Dedication of Library facility in Old State Capitol.
1971	After $254,450 total appropriations, Library has largest collection of Illinois newspapers on microfilm.
August 18	**President Richard Nixon** visits Library and Old State Capitol.
1974	
November 1	Janice Petterchak becomes first Audio Visual curator and has specific photographic responsibilities.
1976	Roger Bridges becomes head librarian and director of research.
1978	National Endowment for the Humanities awards grant to organize prints and photographs department.
September 19	Robert Todd Lincoln Beckwith donates letterbooks of his grandfather, Robert Todd Lincoln, and other Lincoln family material to Library. Final volume of *Illinois Historical Collections* (vol. 38) published.
1979	Historymobile program ends due to breakdown of vehicle.
1980	Library receives $99,266 grant to hire staff to process manuscript backlog.
1981	
November 17	Olive S. Foster appointed state historian.
1984	*Journal of the Illinois State Historical Society* changes name to *Illinois Historical Journal.*
1985	
February 12	Gov. James R. Thompson announces establishment and funding of Lincoln Legal Papers.
April 15	Thomas F. Schwartz becomes curator of Lincoln collection.

April 16	Michael J. Devine becomes state historian and Society executive director.
May 15	Bonnie Ferguson (Parr) becomes first historical documents conservator.
ca. early summer	Library purchases documents at King V. Hostick auction.
July 1	Gov. James R. Thompson creates Illinois Historic Preservation Agency (IHPA); includes Library and state historic sites in new agency. Roger Bridges becomes head of Library Division (director).

1986

January	Library holdings are estimated at 160,000 printed volumes, 9,000,000 manuscripts, 60,000 reels microfilm, 200,000 prints and photographs, and 60 file drawers of ephemera.

1987 Janice Petterchak becomes director of Library.

1989

November	Illinois Newspaper Project to catalog newspapers statewide begins.
November 25	Library celebrates 100th anniversary with party involving authors, storytelling, music, tours, and cake.

1990 Library receives grant to transfer nitrate negatives to safety film.

1991

June	E. Duane Elbert appointed state historian and Society executive director.

1993

February 8	Library begins moving most of its books and manuscripts to Howlett (formerly Centennial) Building for major climate control system installation.
August	IHPA trustees decide to no longer pay salary of Society executive director so state historian will no longer hold post.

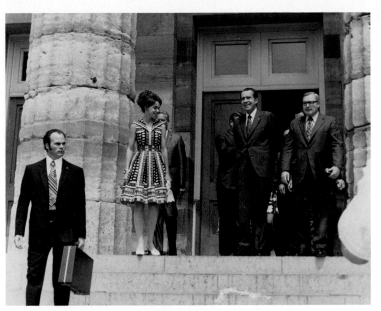

Julie Nixon Eisenhower, President Richard M. Nixon, Illinois governor Richard Ogilvie, and Secret Service agents leaving Old State Capitol, August 18, 1971

On August 18, 1971, **President Richard M. Nixon** visited the Library when he signed a bill in the Hall of Representatives establishing the Lincoln Home National Historic Site. Library staff members assisted with a week of preparations for the event, while continuing to perform patron services (except on the date of Nixon's visit). Secret Service agents searched all parts of the Library, including every drawer, bookshelf, manuscript file, and flower pot, three times as part of their security precautions.

1993 October–
August 1994 "The Last Best Hope of Earth" col-
laborative Lincoln exhibit, co-curated
by Thomas F. Schwartz, displayed
at Huntington Library, San Marino,
California.

1993
November 19 Thomas F. Schwartz appointed state
historian.

1994 Kim Matthew Bauer becomes Lincoln
curator.
April 4–20 Library materials return to Old State
Capitol.
Summer Nitrate film transfer grant completed.

1995
Spring Library and Society each receive $1.43
million from estate of collector King
V. Hostick.
March–April Library installs movable shelving in
one storage room.

1996 February 12–
February 13, 1997 "The Last Best Hope of Earth"
Lincoln exhibit at Chicago Historical
Society.

1996
March 18 Kathryn M. Harris becomes Library
director.
ca. Summer Library installs online catalog in read-
ing room.
First Hostick research awards granted
to doctoral students.

1998 "Looking for Lincoln" begins as heri-
tage tourism project.
Summer Illinois State Historical Society decides
to publish a separate journal, no longer
in conjunction with Library and
IHPA.
Autumn IHPA begins *Journal of Illinois History*
as successor to previous Library/
Society joint publications.

December 15 Helmuth, Obata, and Kasselbaum, Inc.
of St. Louis announced as architects for
prospective Abraham Lincoln Presiden-
tial Library and Museum (ALPLM).

1998 December–
January 1999 First meetings of core panel of
historians for ALPLM.

1999
February 12 Gov. George Ryan announces $4.9
million appropriation for ALPLM
planning and design.
November 16 Gov. George Ryan unveils initial
ALPLM designs.

2000
August 11 Gov. George Ryan announces rede-
signed ALPLM plans.

2001 Expansion of Lincoln Legal Papers
into Papers of Abraham Lincoln em-
braces all materials by and to Lincoln
during any period of his life.

2001
February 12 Groundbreaking for ALPLM.

2002
June 10 ALPL cornerstone placed.
November 18 ALPL dedication ceremony.

2003
October 1 Richard Norton Smith appointed first
director of ALPLM.

2004
October 14 Gov. Rod Blagojevich officially opens
ALPL almost two years after dedi-
cation, due to faulty climate control
system.

2005
April 16–19 Four days of festivities including block
party, concert, fireworks, two-day
scholarly conference, and dedication
ceremony with President George W.
Bush and Senators Barack Obama and
Dick Durbin open Museum.

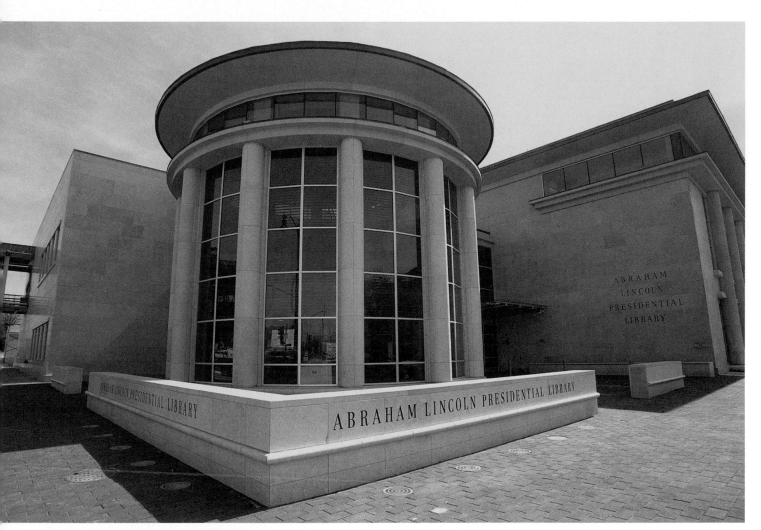

Abraham Lincoln Presidential Library exterior

Abraham Lincoln Presidential Library reading room, 2013

2005—*continued*	Library begins mounting frequent atrium exhibits featuring holdings.
2006	
November	Rick Beard becomes director of ALPLM.
2007	
May	James M. Cornelius becomes Lincoln curator.
2008 April– May **2009**	"Abraham Lincoln: Self-Made in America" truck exhibit travels the country.
2008	Lincoln Legal Papers concludes with publication of selective edition of legal documents and case descriptions. Papers of Abraham Lincoln continues.
2010	
December	Eileen R. Mackevich appointed executive director of ALPLM.
2013	
June	Library holdings are estimated at 250,000 printed volumes, 12 million manuscripts, 103,000 reels microfilm, 500,000 prints and photographs, 3,000 maps, almost 1,600 items with Lincoln handwriting, and 50,500 other items related to Lincoln.

2. *Organization of the Library*

The Library began collecting and preserving Illinois-related historical material as soon as it was organized in order to fulfill its legislative mandate. Over time, "Illinois-related" came to include not only material about Illinois directly but also items pertaining to other states and countries that are associated with Illinois natives or residents who spent some of their career outside the state.

In the early days, the Library was not organized into separate departments as the Library is arranged today, even though the Library collected Lincoln material, manuscripts, newspapers, and photographs, as well as printed and published materials. As each section came to consist of enough material to require specialized assistance for users, separate departments were established.

"Printed and Published" brings all types of books to mind—reference materials, bibliographies, indexes, monographs, family histories, and city directories, for example. But this department also contains numerous runs of historical journals and other periodicals (many from outside Illinois), blueprints of some historic sites, and a wide variety of historical maps. In addition, the department has a large vertical file of ephemeral publications (programs, clippings, pamphlets, etc.) on many Illinois subjects. Reference librarians also assist researchers in using a number of databases for genealogical and historical study.

◆

Are guinea pigs truly pigs? That question is the focus of Ellis Parker Butler (1869–1937) in his hilarious tale *Pigs Is Pigs* (1906). Ward Schori (1908–1994), a prize-winning miniature book publisher from Evanston, Illinois, selected this story as one of at least eighty poems, stories, and historical accounts that he produced in miniature format. All of Schori's books are less than three inches in height or width, and some are less than two inches in both dimensions. Some titles are bound using ordinary cloth, while many others are

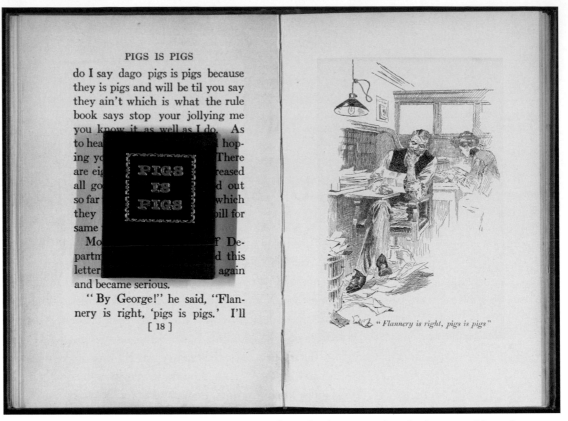

Pigs Is Pigs, miniature book published by the Press of Ward Schori, 1990 (2½″ high × 2″ wide), with 1906 original edition (sixth printing; 7″ high × 5″ wide)

Case full of miniature books; snakeskin-bound volume, top row, tenth from left; *Pigs Is Pigs*, top row, far right (case: 10″ high × 9¾″ wide)

leather or velvet, some with gilt lettering and designs, some with hand painting. Several have tiny slipcases for the volume. One, *Snake-Handling Sunday in the Blue Church* by Annabel Thomas (1985), is bound in python skin.

This special collection of volumes was purchased by the Library in 1995. Schori, who had signed many of his miniature books, came to Springfield for a reception at the Library after the purchase. The Library's conservation department crafted the unique case to house the miniature volumes.

Introducing Students to the Treasure Hunt

You don't usually expect students to cheer about going to a library, but that is what happens each year as the fifth graders from Iles Elementary in Springfield, Illinois, spend a day at the Presidential Library. The students research an aspect of life in Lincoln's Springfield with the goal of writing and performing a historical play at the Old State Capitol. After several weeks of study, they decide on the specific narrative they want to tell. The last step in their research before writing their script is to go to the Presidential Library to find those specific details about people and events that will make their plays come alive.

The students approach the library with the attitude that they are going to make new discoveries. They pore through books, ledgers, diaries, microfilm, and letters looking to discover new information about their characters and events, and they do. The real treasure, however, is that year after year the teachers, mentors, and staff watch as students discover that history is about real people.

"The thing I remember the most about the library was thinking about how the letters described people's lives who I had never given a second thought to before then. They led a passageway connecting the lives of ordinary people who never wanted to be remembered for any of their memorable actions. Those people did what they did because they cared about the people who they were doing it for."— Abby Milhiser, Iles fifth grader, class of 2012

The Library helps the students make a personal connection with the past. They truly feel that they have embarked on a treasure hunt.

Paula R. Shotwell
Fifth grade teacher
Iles Elementary School, Springfield, Illinois

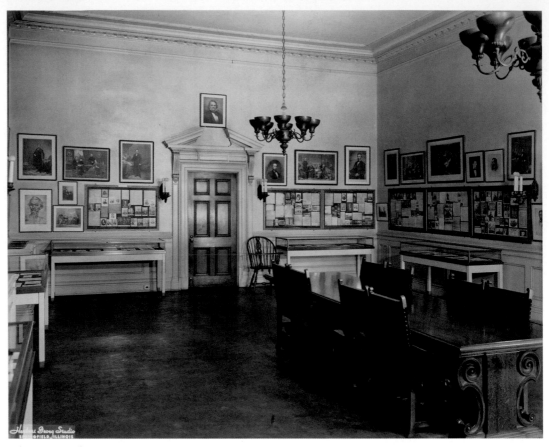

Library Lincoln room, 1938

From the tenure of Paul M. Angle, which began in 1932, through the end of Clyde C. Walton's term in 1967, the state historian and Library director was a Lincoln expert. Materials related to Lincoln were on display, and the Library received or purchased important Lincoln collections such as the Lincoln books of Gov. Henry Horner and some of the Lincoln manuscripts owned by Oliver R. Barrett. In 1958 James T. Hickey became the first Lincoln curator. He was followed in that position by Thomas F. Schwartz (1985), Kim Matthew Bauer (1994), and James M. Cornelius (2007). This department holds all the Library's manuscript materials by (or with any kind of notation by) Abraham Lincoln (nearly sixteen hundred items), 320 documents written by Mary, and 250 books and artifacts owned by the family. One thousand photos, additional portraits and other artwork depicting the Lincolns, fourteen thousand books pertaining to them, and all kinds of Lincoln-related kitsch (Lincoln bandages anyone?) can be found in this department, which has approximately fifty-two thousand items altogether.

Undoubtedly the most famous speech in American history, Lincoln's two-minute comment has become known to posterity as the "Gettysburg Address." However, the main speaker at the dedication of the National Soldiers' Cemetery in Gettysburg, Pennsylvania, on November 19, 1863, was Edward Everett (1794–1865). A Unitarian minister, Massachusetts politician, and noted orator, Everett spoke eloquently for two hours, a speech now largely ignored.

In late January 1864 Everett requested a handwritten copy of Lincoln's address, which he bound into

"Everett Copy" of Abraham Lincoln's Gettysburg Address (each sheet 9½″ high × 7½″ wide; entire frame 22½″ high × 30″ wide)

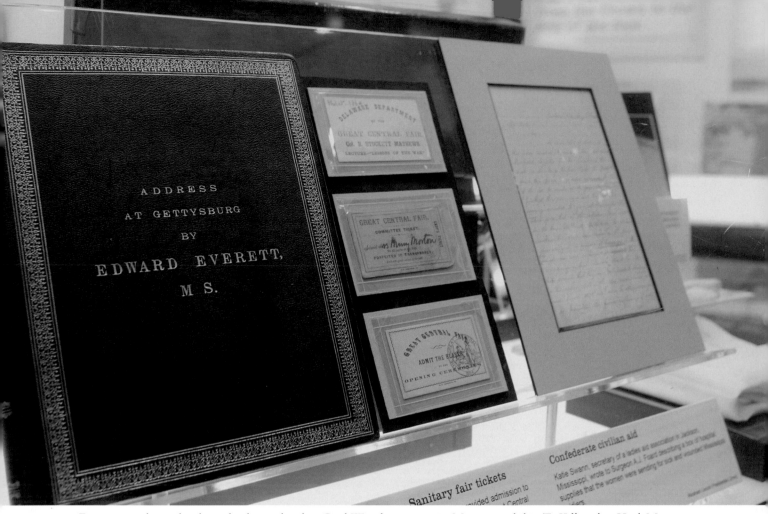

Everett speech notebook on display with other Civil War documents in Museum exhibit *To Kill and to Heal*, May 2012–November 2013

a notebook with a copy of his own speech and donated for sale at the New York City sanitary fair for the benefit of wounded soldiers. The speeches apparently did not sell at the fair but eventually were purchased by a Boston merchant.

This document, the third of five copies of his address handwritten by Lincoln, remained bound with the Everett speech in private collections until 1944. Then, Illinois schoolchildren collected pennies. Those efforts, augmented by a donation from Marshall Field III, allowed for the purchase of the two speeches for $60,000 and presentation of them to the Library. Lincoln's address has been separated from Everett's and framed for periodic exhibition as one of the Library's most important treasures. However, Everett's speech also occasionally appears on exhibit.

The Library began collecting newspapers soon after its founding. In 1904 Jessie Palmer Weber made an agreement with newspaper publishers to send copies of their newspapers to the Library. By 1913 the Library had files of about seventy-five papers. However, the number and weight of the papers as well as lack of space to store them prevented the Library from binding many of them and making them readily available to researchers. Instead, they were arranged in order, wrapped in heavy paper, and piled in a storeroom.

The General Assembly first appropriated money for the Library to microfilm newspapers in 1959. By 1970 the Library had about thirty-seven thousand reels of microfilm and by the following year had the largest collection anywhere of Illinois newspapers on microfilm, a distinction still held by the Library, which now has over 103,000 reels of film. Runs of surviving newspapers from every county in the state and most towns can be borrowed by other libraries through interlibrary loan. In addition to local newspapers, the department also holds some labor, African American, Civil War, foreign language, and other topical papers, as well as microfilm of some manuscript collections. The collection holds selected original historic newspapers. Reading newspapers is one of the best ways for researchers to get a sense of time and place. Newspapers are unmatched primary sources.

Microfilm cabinets in Old State Capitol, 1970

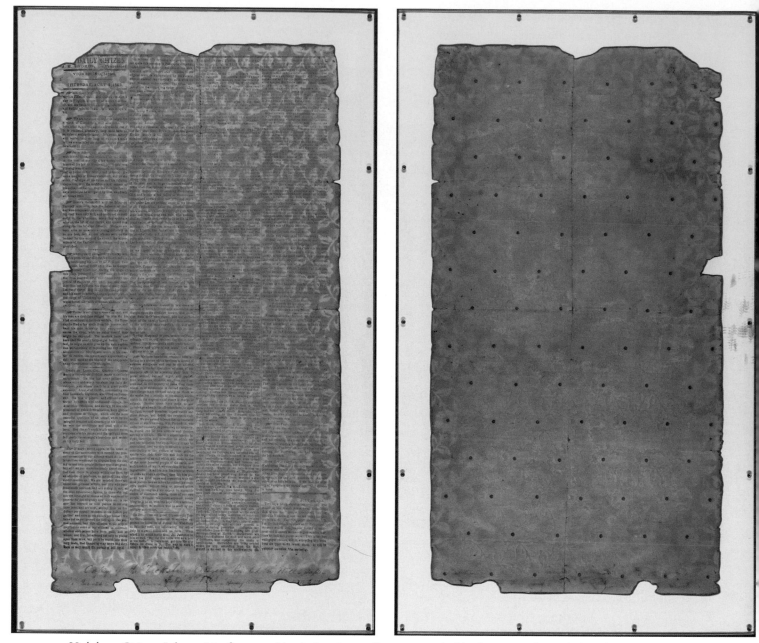

Vicksburg Citizen, July 2, 1863, front, and back showing wallpaper print (19″ high × 10″ wide, excluding frame)

Although Ulysses S. Grant's campaign to capture Vicksburg, Mississippi, had been going on for months, the siege of the town did not begin until May 18, 1863. The besieged Confederate soldiers and civilians suffered not only from weaponry but also from increasing deprivation since supplies could not be replenished.

Even the local newspaper, the *Vicksburg Citizen*, ran short of paper and printed its issues from June 16 through July 2 on the back of sheets of wallpaper. When Vicksburg surrendered to Grant on July 4, J. M. Swords, the *Citizen*'s editor, departed in haste, leaving the type still set for the July 2 issue. Union soldiers discovered this unfinished issue, replaced a section of the lower right column with an update as of July 4, and reprinted the paper on wallpaper.

There are numerous copies and different versions of the paper, with many purported to be originals. This copy is one of the original July 4 printings. Henry Alton, a farmer from Fountain Green, Illinois, a member of Company A, 118th Illinois Infantry, picked up the paper in Vicksburg and eventually gave it to C. C. Tyler, an insurance salesman and notary public in Fountain Green. In 1911 Tyler gave the paper to the Alexander Sympson Grand Army of the Republic (GAR) Post 455 in Carthage, Illinois. It is not clear how the paper came to the Library, but it may have been donated with other GAR material.

The Manuscripts Department welcomed its first curator, Robert L. Brubaker, in 1962. The department contains original primary sources such as letters, diaries, business records, and political papers related in some way to Illinois or Illinoisans. Many manuscript collections arrive with photographs, other audio visual materials, printed matter, newspapers, or Lincoln items that are transferred to the appropriate department. Although the Manuscripts Department does not hold material *by* Lincoln, it has a substantial amount of material *to* and *about* him scattered through numerous collections. At present the department contains an estimated twelve million items. Subjects of interest to researchers include Civil War topics; state legislators, governors, and other politicians, some of them women; slavery and other African American matters; family collections; the WPA; early church records; business ledgers; World War II correspondence; women's organizations; education; agriculture; medicine; and historical anniversary celebrations.

TUCSON, ARIZONA

"The Sunshine Center of America".

March 16-1933

Governor Henry Horner

Springfield Ill.

Dear Governor Horner:

 I am spending the winter in Tucson
Arizona, and knowing how interested you are in all
National and International subjects, I thought of writing
you a copper letter as so many Arizona people are doing
to interest all our country in doing something toward
restoring copper to its rightful place in the metal market,
which as you know can be done by legislation only that
will give us a higher tarff, then by creating a market
for copper.

 If it were possible in one letter I would
try to tell you the dire need of protection that Arizona
stands in need of now.Without the resumption of thier
mining industry they will soon be a ghost state, and we
people of the manufacturing district would surely feel
that for Arizona is one of the coming markets, for when
theybuild here, anything from a corral to a house it is
built of the best and by the best plans, which makes them
a marvelous marketing center for our eastern and northern
products. I regret that I cannot spend more time in Arizona,
and when I return to my business in Chicago I will still
be interested in Arizona's future.

 Wishing you all success and prosperity in
your personal also administrative career I am,
 Sincerely yours. Sol Ellis. 2118 S. State St. Chicago

Letter from Sol Ellis to Governor Henry Horner, March 16, 1933, on thin sheet of copper (11″ high × 8″ wide)

Tucson, Arizona
"The Sunshine Center of America"

March 16-1933

Governor Henry Horner
Springfield Ill.

Dear Governor Horner:
I am spending the winter in Tucson Arizona, and knowing how interested you are in all National and International subjects, I thought of writing you a copper letter as so many Arizona people are doing to interest all our country in doing something toward restoring copper to its rightful place in the metal market, which as you know can be done by legislation only that will give us a higher tariff, then by creating a market for copper.

If it were possible in one letter I would try to tell you the dire need of protection that Arizona stands in need of now. Without the resumption of thier [sic] mining industry they will soon be a ghost state, and we people of the manufacturing district would surely feel that for Arizona is one of the coming markets, for when they build here, anything from a corral to a house it is built of the best and by the best plans, which makes them a marvelous marketing center for our eastern and northern products. I regret that I cannot spend more time in Arizona, and when I return to my business in Chicago I will still be interested in Arizona's future.

Wishing you all success and prosperity in your personal also administrative career I am,

Sincerely yours,
Sol Ellis 2118 S. State Chicago

One of the more unusual manuscripts at the Library is this letter of March 16, 1933, addressed to Illinois governor Henry Horner. His correspondent, Chicago businessman Sol Ellis (1880–1952), was spending the winter in Tucson, Arizona. Ellis, who immigrated to the United States from Russia in 1900, had a plumbing supply business. This probably helps to explain his great interest in the Arizona copper market during the Great Depression.

This letter, part of the 191-linear-foot collection of Horner's papers in the Manuscripts Department, came to the Library in 1947.

Governor Henry Horner among his Lincoln materials

Internship as a Career Influence

During the summer of 2011—after my junior year of college—I was an intern in the ALPL Manuscripts Division. Spending three fascinating months working with the talented and dedicated Library staff provided exciting new experiences, led to a unique historical discovery, and impacted my career decisions.

The new experiences related to my internship duties, which consisted of processing manuscript collections, performing background research on those collections, and updating finding aids and various bibliographic materials. During these months I worked on various collections, from Illinois shopkeepers' records and Civil War letters, to large collections of state and federal legislators, most notably the late Senator Paul Simon. These new experiences employed and strengthened my academic training in history and further enriched my appreciation for and fascination with archives and libraries. My schoolwork and work ethic made for a straightforward transition into this internship. My interest in history made this internship especially valuable, given the chance to work with Illinois-related material.

While examining some miscellaneous papers in an unprocessed collection, I came across two previously unknown documents written by Abraham Lincoln in 1844. Experts in the Papers of Abraham Lincoln project confirmed the handwriting. The resulting notoriety, such as newspaper and other media interviews, from the discovery was an additional benefit from working quietly together in the Manuscripts Division to make Illinois's history available to the public.

Due in large part to my internship at the ALPL, I decided to study for a master's degree at the University of Illinois Graduate School of Library and Information Science. My experiences in the Manuscripts Division shaped my career goal of becoming an archivist. The staff that makes the ALPL inviting and engaging will continue to be a valuable resource in my professional life, as I hope to be to them.

David Spriegel
Gurnee, Illinois

For many years photographs remained filed in the manuscript collections in which they arrived. In 1974 Janice Petterchak became the Library's first Audio Visual curator. Four years later, the National Endowment for the Humanities awarded the Library a grant to organize its prints and photographs. Currently the Audio Visual Department holds approximately five hundred thousand items. The 450,000 photographs exemplify the history of photography, including daguerreotypes, ambrotypes, tintypes, cyanotypes, cartes-de-visite, cabinet cards, stereographs, lantern slides, and glass negatives, as well as more recent slides and prints. Among the subjects documented are aspects of family life, labor, military activities, political events and personalities, cities and towns, transportation, business institutions, and organizations of various types. The department also holds broadsides (posters), cartoons, audio tapes, oral history interviews, reel-to-reel film, and record albums.

Library World War I poster display, probably 1930s

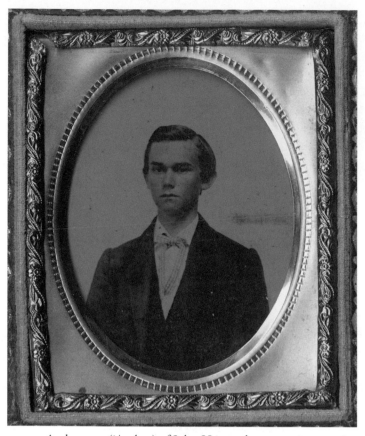

Ambrotype (¹⁄₆ plate) of John Hay at about age sixteen, 1854
(3″ high × 2½″ wide)

Photograph of John Hay late in life by C. M. Gilbert, 1904
(19″ high × 15½″ wide)

Herman Henry Kohlsaat

John Hay (1838–1905), as a young journalist, served as one of President Abraham Lincoln's private secretaries. In addition to writing a multi-volume biography of Lincoln with his fellow secretary John Nicolay, Hay had a distinguished diplomatic career. At the time of his death, he was President Theodore Roosevelt's secretary of state.

On June 23, 1905, Hay autographed this photograph to Herman Henry Kohlsaat (1853–1924), a Chicago newspaper publisher acquainted with many politicians of the era. The Library received much of Kohlsaat's collection of photographs and many manuscripts as a gift from his daughter in 1960, with an addition to the collection by his grandchildren in 1992. The ambrotype was donated by the Episcopal bishop of Springfield in 1926.

The Artifacts Department is the Library's smallest and most recent unit. For many years the Library deliberately collected only Lincoln artifacts. However, new acquisitions of manuscripts and photographs often arrived with other objects that were then boxed and stored with the Lincoln artifacts. These items were never cataloged. Once the Museum opened and the Library began to stage more frequent exhibits of its own, it became clear that these artifacts could be useful. As a result, cataloging of the non-Lincoln objects is in progress. Most of the items are relatively "ordinary" things that are useful for historians as examples of what was readily available at the time the artifact was in use. These might include uniforms and other clothing, weapons, and political memorabilia. Other artifacts are more distinctive and quirky. Several of them have been chosen as treasures for this book.

Dan Walker (b. 1922), a lawyer and independent Democrat, decided to play on his name and publicize his gubernatorial candidacy by walking through Illinois south to north, 1,197 miles in 116 days in 1971. His efforts were successful, and he was elected governor in 1972, serving January 1973–January 1977. Walker was not reelected in 1976. The boots were donated by Walker, along with other materials and artifacts, in 2007.

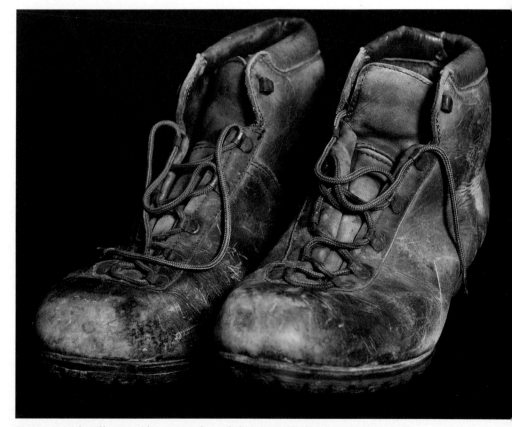

Boots worn by Illinois gubernatorial candidate Dan Walker on his 1971 walk through Illinois (6¼″ high × 4³/₈″ wide × 12¼″ deep)

Some very important sections of the Library do not hold historical collections but serve the Library and its users in support capacities. The Acquisitions Archivist and Librarian handle donations and material purchases. The Cataloging staff assigns call numbers, subject headings, and other finding information for materials from most Library departments. (Lincoln and Manuscripts have their own catalogers). The Microfilming Lab staff prepares and photographs contemporary and older Illinois newspapers. The Conservation Lab staff repairs paper materials from all departments and prepares items for exhibit.

In addition, the Library houses an active oral history project to record and transcribe the recollections of Illinoisans who have had a significant role in state history and politics. Although earlier interviews can be found in the Audio Visual Department, the first oral historian was hired in 2005. The Papers of Abraham Lincoln (successor to the Lincoln Legal Papers)—a digital database project, seeking to identify, house, digitize, and transcribe copies of all manuscripts written by and to Lincoln in all phases of his life—is also located in the Library. The Center for Digital Initiatives is digitizing selected Library collections.

Part Two. The Library's Treasures

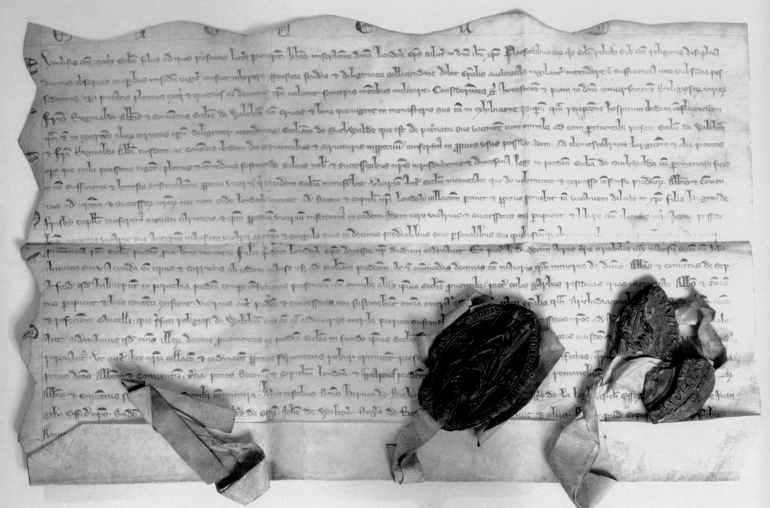

Grant by Johannes I, Bishop of London, 1274 (7″ high × 11″ wide)

3. *"Old Stuff"*

The oldest manuscript, and item of any kind, in the Library is this vellum document precisely handwritten in Latin. In it Johannes I, Bishop of London, made a grant, apparently of a vicarage, to the Abbot of Waltham in 1274. The jagged cut edges, called "indents," indicate that several copies were made of the document. The edges of the copies could be fit together to prevent fraud and show that the document was authentic. Probably there were originally three green wax seals. Although one is missing and one is broken, the third remains intact with the figure on the seal quite clear.

John Chishull, the English name of Johannes I, previously had served as Lord High Treasurer, Lord Chancellor, Archdeacon of London, and Dean

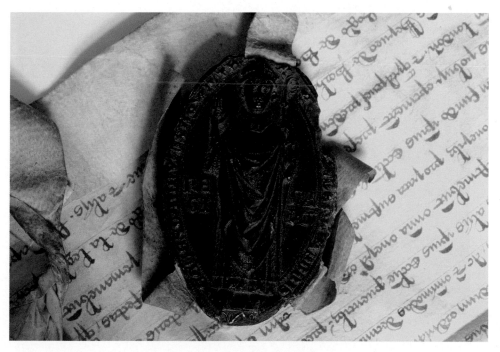

Detail of intact seal

of St. Paul's Cathedral before being elected Bishop of London in 1273. He held the office until his death in 1280.

A document from medieval England would not normally be collected by the Library. However, this item was part of an autograph collection donated to the Library in 1937 by Jesse Jay Ricks (1880–1944), a Chicago lawyer and president of Union Carbide and Carbon Company. Although the collection, with items dating from 1274 to 1903, includes such famous autographs as that of Napoleon I, most of the documents do relate to Illinois history.

———————◆———————

Chronologie septenaire de l'histoire de la paix entre les roys de France et d'Espagne . . . auec le succez de plusieurs nauigations faictes aux Indes Orientales, Occidentales & Septentrionales, depuis le commencement de l'an 1598. iusques à la fin de l'an 1604. This Paris-published 1605 French text written by Pierre-Victor Palma-Cayet, discussing the history of the peace between France and Spain and their voyages of discovery from 1598 to 1604, is the oldest known book in the Library that is still in its original binding. One older volume, an Italian geography published in 1558, was rebound at a much later date.

Chronologie septenaire de l'histoire de la paix entre les roys de France et d'Espagne . . . , by Pierre-Victor Palma-Cayet, 1605 (6½″ high × 4³/8″ wide × 2³/8″ thick)

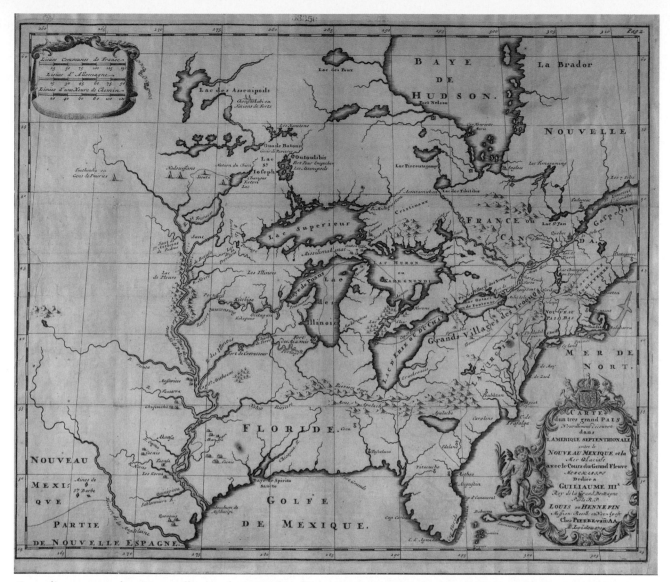

Carte d'un tres grande pais nouvellement decouvert dans l'Amerique Septentrionale, entre le Nouveau Mexique et la Mer Glaciale . . . , by Louis Hennepin, 1704 (15½" high × 18¼" wide)

Father Louis Hennepin (1626–1705), a Dutch Catholic priest and Franciscan missionary, was the chronicler for Robert La Salle's 1678 expedition around the Great Lakes and search for the source of the Mississippi River. Hennepin wrote several very successful exploration books, some of which attributed exaggerated achievements to himself. This map, *Carte d'un tres grande pais nouvellement decouvert dans l'Amerique Septentrionale, entre le Nouveau Mexique et la Mer Glaciale, avec le cours du grand Fleuve Meschasipi . . .* (A map of a large country newly discovered in Northern

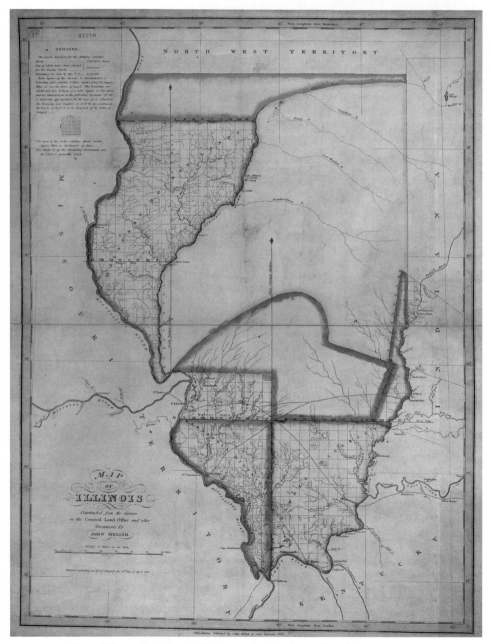

Map of Illinois by John Melish, 1818 (24″ high × 18″ wide)

America situated between New Mexico and the Frozen Sea together with the course of the Great River Mississippi . . .), was published in Leiden, the Netherlands, by Hennepin in 1704. It may have been removed from a copy of one of Hennepin's accounts of his discoveries, also published in 1704. The Library purchased the map in September 1929.

———————◆———————

This map of Illinois was printed in Philadelphia in April 1818, just a few months before Illinois became a state in December. Prepared by John Melish (1771–1822) from surveys in the General Land Office as well as some other documents, the map has several interesting features. Sections of the territory, including the military bounty lands to be granted for service in the War of 1812, are separated with hand-colored boundaries. Also, the northern boundary, as originally drawn for the territory, does not reach Lake Michigan. Nathaniel Pope, Illinois territorial delegate, persuaded Congress to set the boundary further north at 42° 30′, thereby including the lead-mining area near Galena and the future site of Chicago in the new state.

The map was purchased in New York and accessioned by the Library in 1921. While the Library also has a second copy, there are only four other originals known, besides the Library's holdings.

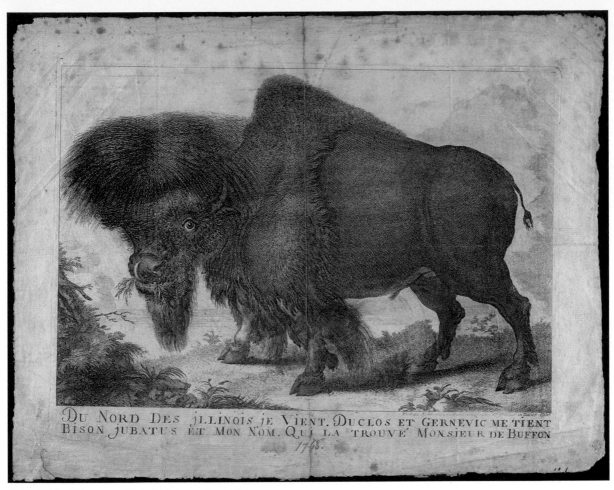

DU NORD DES ILLINOIS JE VIENT. DUCLOS ET GERNEVIC ME TIENT
BISON JUBATUS EST MON NOM. QUI LA TROUVE MONSIEUR DE BUFFON
1768.

Broadside of bison, 1768 (12″ high × 17″ wide)

This broadside of a bison, published in 1768, is the oldest broadside in the Audio Visual collection. It may well have been removed from a book, possibly something for children because the French lines appear to rhyme. The "bison jubatus" mentioned in the text was a term used by the ancient writer Pliny and others after him to refer to a European bison or aurochs. This term evidently was transferred to the new world animal by the artist who prepared this picture.

The rhyme in English:

I come from north of Illinois
I am included in Duclos and Gernevic
European bison is my name
As described by Mr. de Buffon.

Charles Pinot Duclos (1704–1772) assisted in compiling an important French dictionary (1762). George-Louis Leclerc, Count of Buffon (1707–1788), was a French naturalist who published a thirty-six volume natural history (1749–1788). No one named Gernevic could be located.

GEORGE WASHINGTON, President of the United States of America.

To all who shall see these Presents, GREETING.

Know Ye, That reposing special trust and confidence in the Integrity, Ability, and Diligence of Aquila Giles, of New York, I have nominated, and by and with the advice and consent of the Senate do appoint him Marshal of and for the New York district, and do authorize and empower him to execute and fulfil the duties of that office according to law; and to have and to hold the said office, with all the powers, Privileges, and Emoluments to the same of right appertaining, unto him the said Aquila Giles, during the Pleasure of the President of the United States for the time being.

In Testimony whereof I have caused these letters to be made patent and the seal of the United States to be hereunto affixed.

Given under my Hand at the city of Philadelphia, this fourth day of May, in the year of our Lord one thousand seven hundred and ninety two, and of the Independence of the United States of America, the sixteenth.

G. Washington

By the President

Th. Jefferson

Commission of Aquila Giles, May 4, 1792 (12½″ high × 12¾″ wide)

Among the unlikely items in the Manuscripts Department is the commission appointing Aquila Giles (1758–1822) marshal of the New York district on May 4, 1792. This item came to the department in 1940 from the collection of Illinois governor Henry Horner. Giles, a Revolutionary War veteran who lived in Maryland and then New York City with his large family, eventually worked as a U.S. Army storekeeper.

This commission is a treasure because it was signed by President George Washington and then-secretary of state Thomas Jefferson.

The first newspaper published in Illinois was *The Illinois Herald*, printed at Kaskaskia, the territorial capital, from about May 1814 to April 1816, when its name changed to the *Western Intelligencer*. Under yet another title, the *Illinois Intelligencer*, the paper migrated with the new state capital to Vandalia in 1820. Only one issue of the *Herald* is known to exist: the Library's copy of volume 1 number 30, dated December 13, 1814. Although the source of the newspaper is not certain, the Library had it before 1899 when its first bibliography of newspapers was published, so it probably came as part of the original donation from the Illinois State Library.

Matthew Duncan (d. 1844), the paper's printer at the time of the Library's issue, was an older brother of Illinois' sixth governor, Joseph Duncan (1834–1838). Matthew Duncan, a college-educated Kentucky native, served as Illinois territorial printer for several years, but he eventually joined the U.S. Army and served in the Black Hawk War before resigning to become a businessman in Shelbyville, Illinois.

The Illinois Herald, December 13, 1814 (17¼″ high × 11⅛″ wide)

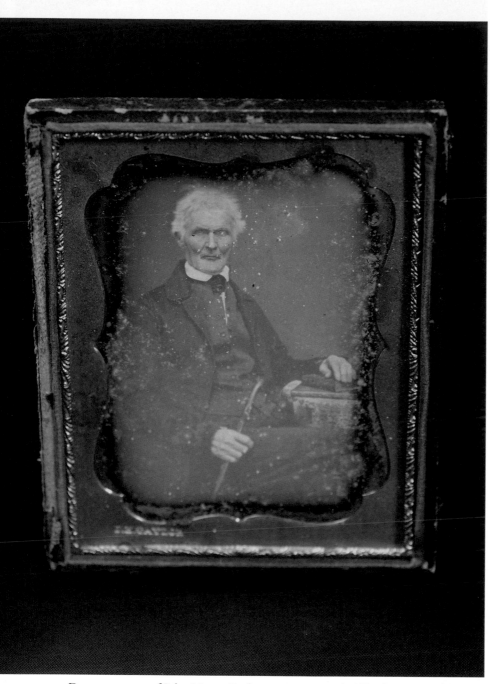

The daguerreotype (named after its inventor Frenchman Louis-Jacques-Mandé Daguerre) was an early kind of photograph that captured the picture directly onto a silver-coated copper plate without using a negative. The process was popular from its invention in 1839 until the late 1850s.

John Mason Peck (1789–1858) was born in Connecticut but came to the West as a Baptist missionary, first to St. Louis in 1817 and then to Rock Spring, Illinois, in 1822. He organized many Bible societies, established Shurtleff College, raised funds for Baptist missionary endeavors, encouraged the publication of Baptist literature, and sought methods to preserve Baptist history. Peck was an important figure in early Illinois religious history.

The Library has owned the Peck daguerreotype for many years, but it was not identified until about 2002 when staff noticed the resemblance of the subject to the few known images of Peck. This rare image is one of the Audio Visual Department's most important treasures.

Daguerreotype of John Mason Peck, ca. 1840s–1858 (4½″ high × 3¾″ wide)

A gazetteer is a type of geographical encyclopedia that was common in the nineteenth century. This one, titled *A Gazetteer of Illinois* and written by John Mason Peck, was published in Jacksonville in 1834 by three brothers—Thomas, Robert, and Calvin Goudy—students at Illinois College whose father had been a printer in Indiana and Vandalia, Illinois. The subtitle of the book accurately describes its contents: "in three parts, containing a general view of the state, a general view of each county, and a particular description of each town, settlement, stream, prairie, bottom, bluff, etc.—alphabetically arranged." The Goudys claimed that this gazetteer was the first nongovernmental book printed in Illinois.

This copy was a gift from a Rhode Island donor in 1933.

A

GAZETTEER OF ILLINOIS,

IN

THREE PARTS:

CONTAINING

A GENERAL VIEW OF THE STATE; A GENERAL
VIEW OF EACH COUNTY;

AND

A PARTICULAR DESCRIPTION OF EACH TOWN, SETTLEMENT,
STREAM, PRAIRIE, BOTTOM, BLUFF, ETC.—ALPHA-
BETICALLY ARRANGED.

BY J. M. PECK,

AUTHOR OF A GUIDE FOR EMIGRANTS, ETC.

JACKSONVILLE:
PUBLISHED BY R. GOUDY.

1834

A Gazetteer of Illinois, 1834 (6″ high × 4¼″ wide)

in a quart of water; bathe the burn or scald with a linen rag wet in this mixture; then bind the wet rag thereon with a slip of linen, and moisten the bandage with the alum water frequently, without removing it, in the course of two or three days. He relates, that one of his workmen who fell into a copper of boiling liquor where he remained three minutes before taken out, was immediately put into a tub containing a saturated solution of alum in water, where he was kept two hours; his sores were then dressed in cloths and bandages, wet in the above mixture, and kept constantly moistened for twenty-four hours, and that in a few days he was able to return to business.

571. *Remedy for burns.*

A little spirit of turpentine, applied to recent burns, will mitigate the pain, if not wholly remove it.

572. *Another.*

A little sweet oil and lime water shaken together, makes a liniment, which, when kept applied to the part, will remove the pain.

573. *Efficacy of vinegar in curing burns and scalds.*

The application of vinegar to burns and scalds is to be strongly recommended. It possesses active powers, and is a great antisceptic and corrector of putrescence and mortification. The progressive tendency of burns of the unfavourable kind, or ill-treated, is to putrescence cnd mortification. Where the outward skin is not broken, it may be freely used every hour or two; where the skin is broken, and it gives pain, it must be gently used. But equal parts of vinegar and water, in a tepid state, used freely every three or four hours, are generally

the best application, and the best rule to be directed by.

House-leek, either applied by itself, or mixed with cream, gives present relief in burns, and other external inflammation.

574. *Porter plaster for bruises.*

This simple, singular, and safe remedy for bruises, is nothing more than a gallon of porter simmered in an earthen vessel, till, when cool, it will be of the consistence of a plaster. This preparation was spread on an old glove, and applied round the ancle of a coachman, who was thrown off his box, and miserably bruised. In three days it so effectually performed a cure, that he was enabled to remount his box, perfectly relieved from all swelling and pain.

575. *Easy method of attracting earwigs from the ear.*

A person lately having an earwig crept into his ear, and knowing the peculiar fondness that insect has to apples, immediately applied a piece of apple to the ear, which enticed the creature out, and thereby prevented the alarming consequences which might otherwise have ensued.

576. *To kill earwigs, or other insects, which may accidentally have crept into the ear.*

Let the person under this distressing circumstance lay his head upon a table, the side upwards that is afflicted; at the same time let some friend carefully drop into the ear a little sweet oil, or oil of almonds. A drop or two will be sufficient, which will instantly destroy the insect, and remove the pain, however violent.

577. *For a pain in the ear.*

Oil of sweet almonds two drams, and oil of am-

The New Family Receipt Book by Maria Eliza Ketelby Rundell, 1819, p. 283 (7″ high × 4″ wide, closed)

Maria Eliza Ketelby Rundell's (1745–1828) *The New Family Receipt Book* (1819) was a type of nineteenth-century self-help manual. According to the book's subtitle, it contained "eight hundred truly valuable receipts in various branches of domestic economy, selected from the works of British and foreign writers, of unquestionable experience and authority, and from the attested communications of scientific friends." This compilation of recipes included directions for cooking, making medicines, and preparing concoctions to help with cleaning and domestic repairs. Rundell's

proposed audience was "the Good House Wife—the Honest Farmer—the ingenious Mechanic." Manuals such as Rundell's were published in Europe (Rundell was British) as well as the United States and crossed the ocean in the luggage of many immigrant women.

Recipe number 575 on page 283 provides helpful advice on an "Easy method of attracting earwigs from the ear." The remedy was to place a slice of apple near the ear to lure the insect out.

The Library purchased this volume in 1967.

Fascinating Information

The Abraham Lincoln Presidential Library and Museum and its staff are treasures. As a local history columnist, playwright, and book author, I couldn't do my job without them. I rely on the ALPLM and its experts for help writing articles, radio and video documentaries, plays, and scripts—and to satisfy my personal curiosity about the historically rich town and state where I live.

The Library's collections of old newspapers and manuscripts helped me investigate and solve the question of whether or not Abraham Lincoln had purchased cocaine in Springfield, as some historians claimed (he had not), which resulted in articles for my book, *Stories of Springfield: Life in Lincoln's Town*, and the *Chicago Tribune Magazine*. Their photos and illustrations have brought the past alive for articles and documentaries I've written on topics such as the Civil War, Illinois' Old State Capitol, Springfield's race riots, and more. Their staff have helped me answer questions about Lincoln's life, work, family, friends, and colleagues, as well as Civil War medicine, and African American history in our state.

Whenever I'm working on a project that relates to Springfield or Illinois history, I use the ALPLM. I always wonder what fascinating information I'll find there next!

Tara McClellan McAndrew
Springfield, Illinois

4. *Locations*

A camera lucida used a prism and mirrors to project an image onto paper or canvas so that it could be traced. Basil Hall (1788–1844), a British naval officer, traveled with his family in the United States in 1827–1828. The following year he published three volumes of *Travels in North America* as well as this book *Forty Etchings, from Sketches Made with the Camera Lucida, in North America, in 1827 and 1828*. Among the other subjects he illustrated

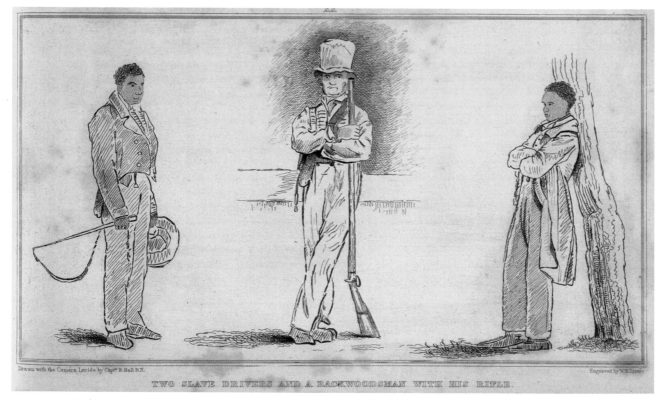

Etching No. XX: "Two slave drivers, and a backwoodsman with his rifle" (single page: 12″ high × 9″ wide)

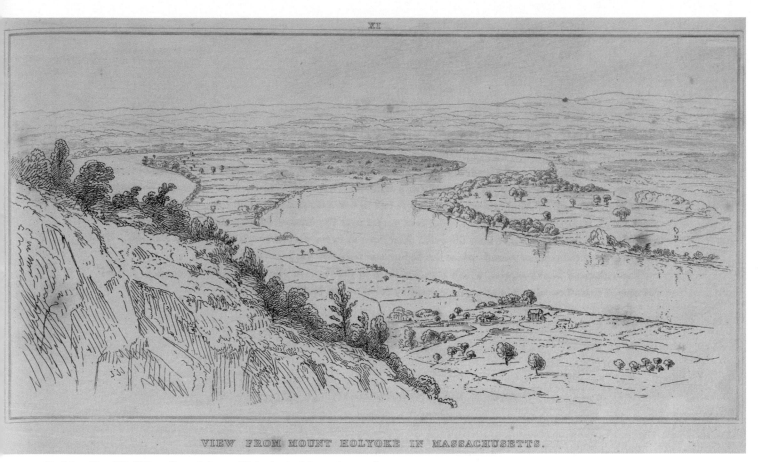

Etching No. XI: "View from Mount Holyoke in Massachusetts"

were a dock view on the Erie Canal at Buffalo, New York, soon used by the Staffordshire pottery company in England as an image on whiteware plates. His "View from Mount Holyoke in Massachusetts" influenced the American landscape painter Thomas Cole when he created his very important work *The Oxbow*.

Among the Library's earliest acquisitions, the Hall etchings were purchased in 1901.

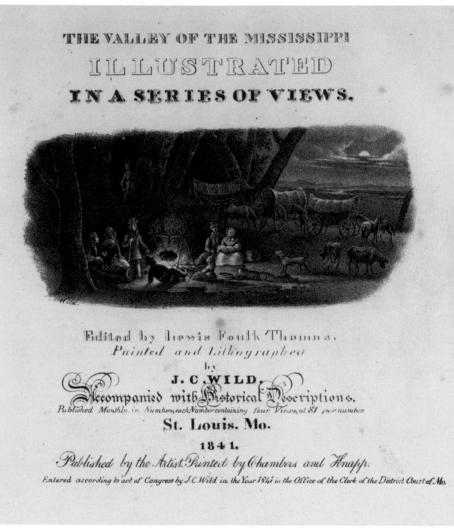

THE VALLEY OF THE MISSISSIPPI
ILLUSTRATED
IN A SERIES OF VIEWS.

Edited by Lewis Foulk Thomas.
Painted and Lithographed
by
J. C. WILD,
Accompanied with Historical Descriptions.
Published Monthly in Numbers, each Number containing four Views, at $1 per number
St. Louis. Mo.
1841.
Published by the Artist. Printed by Chambers and Knapp.
Entered according to act of Congress by J. C. Wild in the Year 1841 in the Office of the Clerk of the District Court of Mo.

Title page of *The Valley of the Mississippi*, edited by Lewis Foulk Thomas, 1841 (11½″ high × 9½″ wide)

The Valley of the Mississippi: Illustrated in a Series of Views, contains some of the earliest images of scenes along the Mississippi River, including the first state capital, Kaskaskia. Other illustrations featured Starved Rock and the Piasa Bird. Edited by Lewis Foulk Thomas (1808–1868), with paintings and lithography by John Caspar Wild (ca. 1804–1846), the work was not published as a book but in nine monthly issues, each with four views.

The Library purchased this work in 1941.

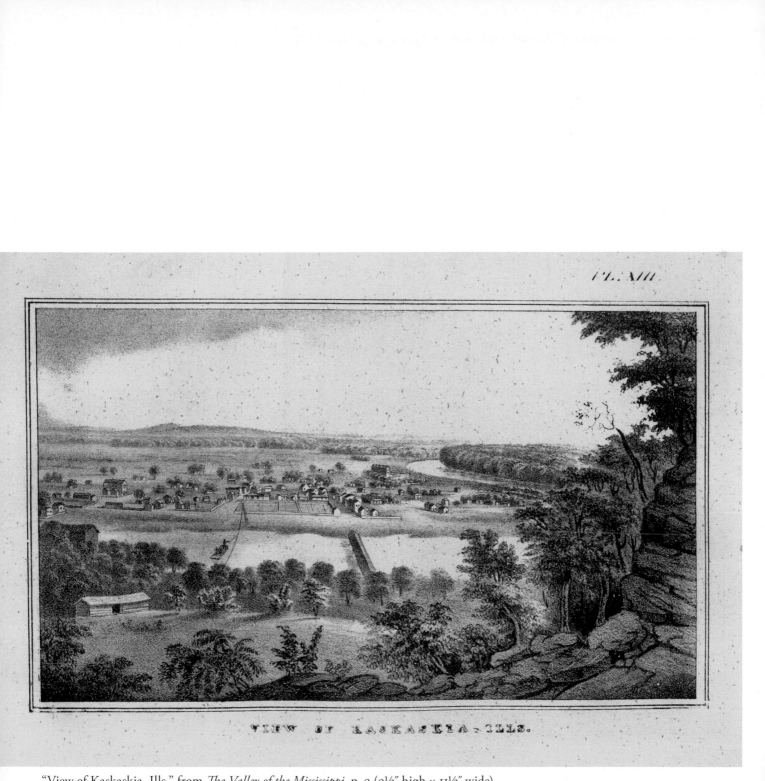

"View of Kaskaskia, Ills." from *The Valley of the Mississippi*, p. 9 (9½" high × 11½" wide)

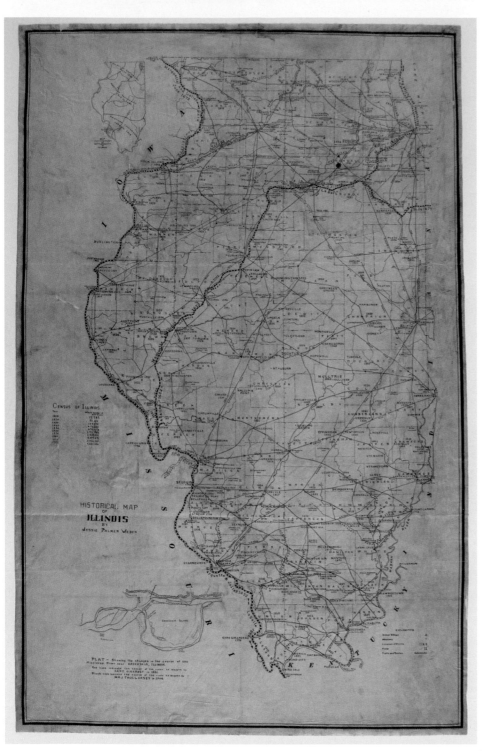

Jessie Palmer Weber, librarian of the Illinois State Historical Library (1898–1926), prepared this map in ink on drafting linen as part of the Illinois historical exhibit for the 1907 Jamestown Tercentennial Exposition. Weber based her map on Rufus Blanchard's 1883 historical map of Illinois. To augment this, she sent maps to historians in each county asking them to include local historical sites and events. A number of the replies can be found in the Library's map collection. One of the events she included, in the bottom left corner of the map, is the Mississippi River flooding that separated Kaskaskia, the original Illinois capital, from the state and made it an island.

Detail of section of *Historical Map of Illinois*

Historical Map of Illinois by Jessie Palmer Weber, ca. 1904
(48″ high × 30⅝″ wide)

Weber's map probably was later exhibited at the Panama-Pacific Exposition in San Francisco, California (1915). The original map is occasionally included in Library exhibits, and a framed reproduction hanging in the reading room remains popular with visitors.

◆

In the early years of photography, cameramen sometimes focused on small-town business districts. Tintypes (also known as ferrotypes), patented in 1856, were quicker and cheaper to produce than the earlier daguerreotypes and ambrotypes. The image of a person or scene was recorded directly on a coated sheet of iron without the use of a negative. As a result, the image was reversed. While this was not usually noticeable with people, signs appear with backwards lettering. This tintype of the north side of the commercial square in Washington, Illinois, was probably taken in the late 1850s. It shows the Ross Zinser & Co. wagon shop, R. D. Smith dry goods, and a German bakery.

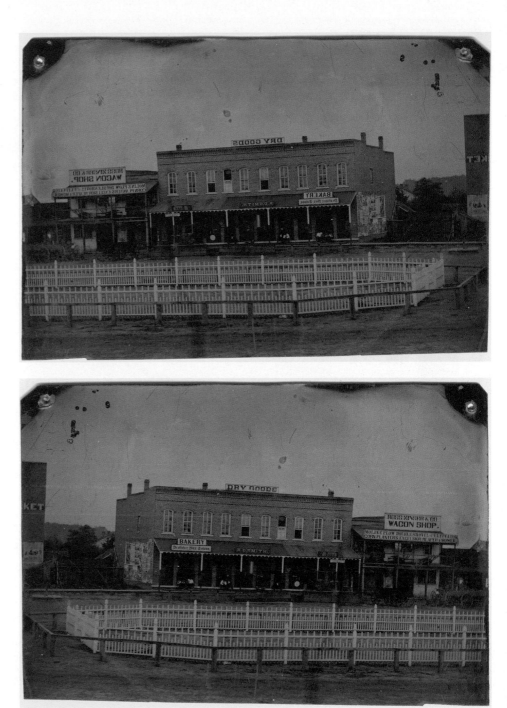

Tintype of commercial square, Washington, Illinois, late 1850s, reversed and corrected (2¾″ high × 4⅛″ wide)

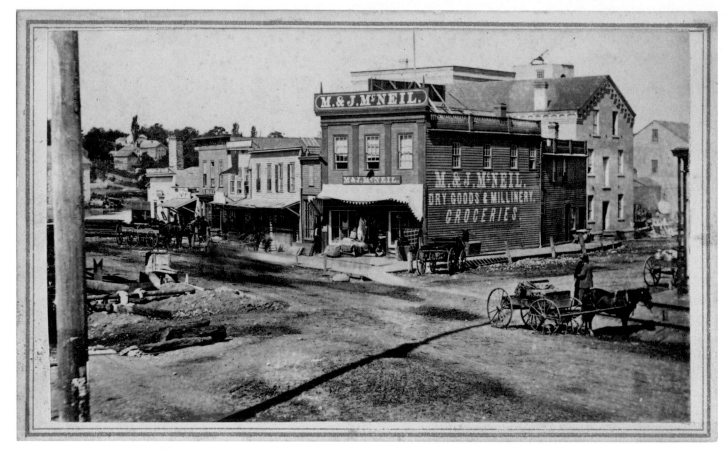

Carte-de-visite of downtown Elgin, Illinois, R. W. Dawson, photographer, 1864–68 (2½″ high × 4″ wide)

Cartes-de-visite (CDVs), visiting card–size photographs, were the rage during the 1860s. Because they were made from negatives and could be reproduced in quantity, CDVs of famous people as well as friends and relatives, some of them Civil War soldiers, were collected in many households. CDVs of scenery were less common but also available. This photo of downtown Elgin, Illinois, featuring the dry goods and groceries store of M. and J. McNeil, was taken by R. W. Dawson between 1864 and 1868. It and four other Elgin photos from the period were donated to the Library in 1977.

A Life with the Library

When I was a child in Springfield, my father worked for the state treasurer in the State Capitol Building. He often took me to work with him on Saturday mornings. I was set loose to explore all of the nooks and crannies of that massive old Victorian structure. After a while, my father allowed me to go next door to the Centennial Building. There I was fascinated by its Hall of Flags and State Museum exhibits and awed and somewhat intimidated by the great reading room of the Illinois State Library with the Historical Library at one end. Its magnificence and size left no doubt that this was an important place, an almost sacred place, where people came to read.

In high school, I used the Library to do research. It was cool to look up a subject, write down all of the letters and numbers of the classification system identifying the book, and take the slip to the desk. A few minutes later, the book magically appeared. Thus my birth as a bibliophile.

In 1970, the Historical Library moved to the lower levels of the Old State Capitol. It was the perfect place for delving into all things Illinois—books, manuscripts, photographs, maps, broadsides.

While I was an attorney with offices in downtown Springfield, the Library was an ideal place to escape the daily routine for an hour or two. I could walk across the street and enter into another world—one filled with people and events from Illinois' past.

In 2002 a monumental new state-of-the-art facility for the Historical Library collection was dedicated and given a new name—the Abraham Lincoln Presidential Library. Now, as I approach retirement, I will have more time to continue exploring all divisions of the Library—general reading room, newspapers, photographs, manuscripts, and the Lincoln collection. Perhaps more than ever, the Library continues as an important place, an almost sacred place, where people come to read.

We should cherish it and we must nurture it for future generations.

Richard E. Hart
Attorney, Springfield, Illinois

Illinois state highway map with annotations of trip from Bloomington to Cairo, 1928 (24½″ high × 15½″ wide)

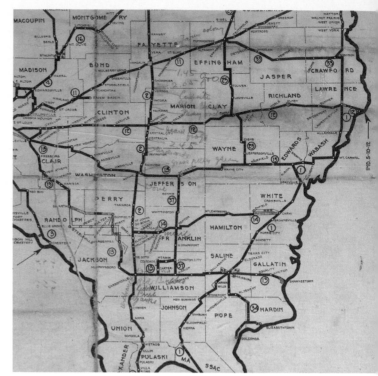

Detail of annotations on highway map

Bloomington—
　Start—3/11/28—10:30
　a.m.
Forsyth—11:45
Moweaqua—12:00
Shrike (south of
　Assumption)
Moraine　　”
Pana—Ar. 12:30—Gray
　Swan Café
　Lv. 12:50
(almost to) Vandalia—
　Farm colony
Vandalia—1:45
(near) Vernon—2:05 G & O
　Camp site
south of Patoka—Blue bird
　M (?) orchard

Sandoval—Heard frogs
Centralia—2:45
north of
　Irvington—Orchards
Ashley—grass getting green
(south of Ashley) Dove
DuQuoin—strip mine
Carbondale—4:35
Orchards
Red　　　　Birches
Cedar
Pine
Ozarks
Cairo—262
　Ar 6:30 p.m 3/11/28
　Colonial Hotel

This appears to be a rather ordinary 1927 Illinois highway map, showing the progress of Governor Len Small's attempt to encourage the construction of "hard" (paved) roads in the state. However, on March 11, 1928, Frank W. Aldrich of Bloomington used the map to make pencil notations tracing his trip down what is now U.S. Route 51 from Bloomington to Cairo. Although brief, his comments indicate natural and manmade physical features, increasing signs of spring, and how long the journey took.

Aldrich presented the map to the Library in 1938.

◆

Several bridges over Illinois waterways were built during the Great Depression–era governorship of Louis Emmerson (1929–1933). Opening ceremonies for these bridges were shot with 35 mm nitrate movie film. As it ages, nitrate film deteriorates and becomes highly flammable. To preserve this film for future generations, the Library had the film professionally transferred to both VHS and DVD formats.

The four central stills, in the example taken from these films, feature the Joe Page Bridge in Hardin, Illinois, being raised to allow river traffic to pass beneath it and then crowded with automobiles after it has been lowered. This bridge, dedicated on July 23, 1931, was completely renovated in 2004 and is still in use. The first picture shows Governor Emmerson participating in the dedication of the Pekin bridge on June 2, 1930. The final frame shows the Pekin band on the new bridge. This bridge was replaced in 1982 by one made of steel girders.

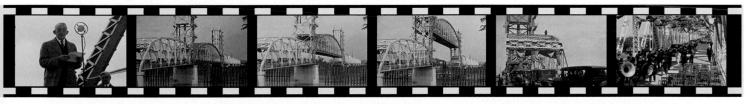

(*Left to right*) Governor Emmerson speaking at dedication of Pekin bridge, 1930; Joe Page Bridge in Hardin down, 1931; Hardin bridge halfway up, 1931; Hardin bridge up with tug boat, 1931; traffic crossing Hardin bridge, 1931; Pekin band on new Pekin bridge, 1930

Articles of agreement made and concluded
this first day of November 1830 —

Between John Savage of Morgan county of
of the first part and John B. Broadwell
and William Lamme of Sangamon county
in the state of Illenois of the second part I John Savage
of the first part covenant promise and agree to
build two flat boats sixty or sixty five feet
long or more and sixteen feet broad and six feet
high with gunnels two feet wide or more for
John B Broadwell and William Lamme of the
second part for the sum of One hundred and
sixty dollars the s^d John B Broadwell and
William Lamme will furnish the plank for
the s^d boats at Bairdstown and Savage
all other materials. the s^d John Savage agrees
and binds himself under the penalty of one thousand
dollars to the s^d John B. Broadwell and William Lamme
and their heirs to compleat finish staunch and caulk

John Savage flatboat contract, November 1, 1830, p. 1 (12⅛″ high × 7¾″ wide)

5. *Business*

On November 1, 1830, in Illinois, John Savage contracted to build two flatboats to certain specifications by December 1 "for the New Orleans trade." Lumber would be provided, and Savage would be paid $160. Although flatboats were used extensively on the rivers of the United States well into the nineteenth century, they are rarely described in as much detail as is found in this document. In fact, this information was also used to help construct the replica flatboat at Lincoln's New Salem State Historic Site near Petersburg, Illinois. The Library received this document as a gift in 1981.

Articles of agreement made and concluded this first day of November 1830————Between John Savage of Morgan county of of [*sic*] the first part and John B. Broadwell and William Lamme of Sangamon county in the state of Illinois of the second part. I John Savage of the first part covenant promise and agree to build two flat boats sixty or sixty five feet long or more and sixteen feet broad and six feet high with gunnels two feet wide or more for John B Broadwell and William Lamme of the second part for the sum of one hundred and sixty dollars. the s^d John B. Broadwell and William Lamme will furnish the plank for the s^d boats at Bairdstown and Savage all other materials. the s^d John Savage agrees and binds himself under the penalty of one thousand dollars to the s^d John B. Broadwell and William Lamme and their heirs to compleat finish stanch and caulk

[p. 2] the two sd flat boats sufficently safe secure navigable and arid for the New Orleans trade one to be finished in the above described manner at or about the twentieth day of November and the other the first day of December 1830

I John Savage have rec^d the sum of one hundred dollars for the above contract the first day of November 1830. the s^d J. B. Broadwell and William Lamme will pay the s^d John Savage the remaining sixty dollars the first of March 1831. As testimony of the s^d compact contract and agreement we set our hands and affix our seals this first day of November 1830 in the presence of

Danl C. Lynch	John Savage
William Simpson	J. B. Broadwell
	William Lamme

[*Note along the left side of the first page*] N. B. the s^d John B. Broadwell and William Lamme agree to pay the s^d John Savage one dollar per foot for the additional number of feet in extra over or more than the sixty feet in length

Thomas Yates general store daybook, 1835–37, pp. 218–19 (12½″ high × 15″ wide, open)

In the nineteenth century, store-keepers kept track of their customers' transactions in daybooks (lists of purchases and payments arranged by date of action) and ledgers (arranged by name of customer). This daybook came from a general store in Berlin, Illinois, run by Thomas Yates, brother of Illinois's Civil War governor Richard Yates. The book contains accounts from March 2, 1835, through July 31, 1837. Because Berlin is not far from New Salem, Illinois, and this book comes from the period when Lincoln lived in New Salem, staff members at the historic site have used this daybook to determine the kinds of things Lincoln might have purchased or carried in his own store.

This daybook, a gift to the Library in 1976, represents a number of early nineteenth-century business records, mostly from central Illinois, that are held by the Library.

In the daybook "To" and "D" indicate a purchase or debit; "By" and "C" indicate a payment or credit. Decimal points have been added to the figures for clarity.

Berlin Ills November 13th 1835

328 James Rhea & wife	D		
To Bolon Bed tick	2.68¼		
1½ y Table Linen	.68¾		
1 Large Tin cup	.25		
1 pair Blanketts	6.50		
1 set cups & saucers	.37½		
1 Box pills	.37½		
1 oz Rhubarb	.12½	11.00	
424 John Faulch Jr & wife	D		
To 1 set Plates	.37½		
1 " Chnai [sic] Teas	1.37½		
1½ y" Table Linen	.68¾		
2 Tin cups	.12½		
1 Large Tin cup	.18¾		
2½ Coffee	.50		
1 Tin pan	.37½	3.63	
315 Abram Faulch	D		
To 2 pair shoes 1.37	2.75		
5 Yds C Flanne [1]	1.25	4.00	
316 Hiram Baily	C		
By 15 Butter	1.50		
To 5 Coffee	1.00		
½ spice	.18¾		
1 pair Boots	4.50	5.69	
326 William Craig	D		
To 1 pair shoes	1.62½		
1 " do	1.50		
1 " do	1.37½	4.50	
Sept Adam Windgardner	D		
To 1 pair gloves		.63	
344 Henry Yates	C		
By Buff for H. Ellis	2.63		
312 Thomas C Gilliam	C		
By 48 Hide	2.40		

Berlin Ills November 14th 1835

335 James Mcdaniel pr son	D		
To ½ salts			.13
429 Frederick Hammar	D		
To 19½ Iron 8	1.56		
1 Almanack	.12½		1.69
430 John Shain	D		
To 7 sugar	1.00		
59½ Iron 8	4.76		
1 Almanack	.12½		5.88
By cash		2.00	
329 G. W. Delzell	D		
To 8 pains Glass	.40		
9 Yds circassian	5.00		
1 set spoons	.37½		
1 skein silk	.06¼		
7 Sugar	1.00		
2½ Coffee	.50		
1 Tea Y H	1.00		
½ Nails	.06¼		
1 Tobacco	.25		
Cash	20.00		29.65
312 Thomas Gillian	D		
To 4 nails			.40
365 Isac Foster	C		
By cash	3.93¼		
365 Isaac Foster	D		
To 1 Hat			4.50
344 Henry Yates	C		
By Foster Isaa	4.86		
330 William Hope	D		
To 2½ Coffee	.50		
¼ Pepper	.12½		.63
# Jas Scott	C		
By cash	2.17		
344 Henry Yates	C		
By F Foster	15.00		

Historic Background for Historic Sites

For over twenty-five years the Illinois State Historical Library (since 2004 the Abraham Lincoln Presidential Library) has been the object of almost daily visits by myself and colleagues as we work to interpret Illinois' state-owned historic sites and memorials. A few highlights . . .

Small but important events in the lives of residents of 1830s New Salem are documented by collections in the Library's manuscripts division. They record marriages, goods and services, trades and debts incurred between village residents, and occasional acts of violence that brought sanction by the local justice of the peace.

Official happenings in the capitol buildings at Vandalia and Spring-field are documented in a large volume of government records. Where legislative journals tend to provide a "just the facts" outline of debates, newspapers in the Library's collection provide enlightening (albeit often partisan) accounts of many events. The newspaper collection is also a major source for the role played by the statehouses in the social and cultural lives of Illinoisans.

Where collections specifically representing a historic site do not exist, the Library's holdings can still provide insight. What goods did a major 1840s central Illinois retail/wholesale store stock? In what amounts? Through what supplier? Check the detailed inventories and shipping records of Lacon merchant William Fisher to find out.

The homes of Pierre Menard near Chester and David Davis in Bloomington can tell us important stories about the past because of the phenomenal collections of papers created by the two families and held today by the Library.

Happily, the relationship between the historic sites division and the Library is not entirely one-way. Research during the early 1980s into the history of the newly acquired Dana-Thomas House in Springfield led to the acquisition by the Library of the Earl R. Bice papers. The collection contains hundreds of documents relating to the house and its owner, Frank Lloyd Wright client and socialite Susan Lawrence Dana.

Mark L. Johnson
Illinois Historic Preservation Agency, Springfield

Joseph Smith (1805–1844), founder of the Church of Jesus Christ of Latter Day Saints (Mormon Church) and translator of the *Book of Mormon*, joined many of his followers in Illinois in 1839 where they settled in a town they renamed Nauvoo. There they built a temple, and Smith began to further refine aspects of Mormon beliefs. On February 24, 1842, Smith authorized Ebenezer Robinson to print fifteen hundred copies of the *Book of Mormon*. Smith's unconventional teachings, plus the political influence of the consolidated Mormon settlement, led to many conflicts with non-Mormons in the area. After Smith was imprisoned in Carthage, Illinois, for allegedly inciting a riot to destroy an anti-Mormon newspaper, a mob murdered Smith in the jail on June 27, 1844.

The Library purchased this document in 1972. It is part of at least ten collections in the Manuscripts Department that relate to various aspects of Mormon history. Period newspapers on microfilm and printed works are also available for students of early Mormonism.

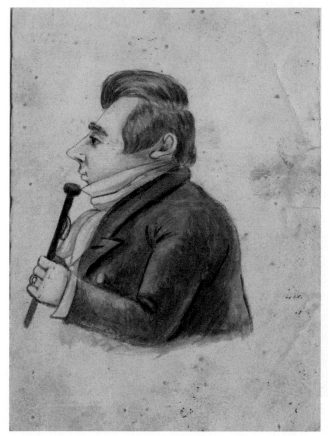

Joseph Smith authorization for Ebenezer Robinson to print copies of the *Book of Mormon*, 1842 (4½″ high × 8³/8″ wide)

Life sketch of Joseph Smith at a federal court extradition hearing in Springfield, Illinois, by Benjamin West of Rochester, Illinois, 1843

This mahogany shelf clock, used in the Springfield law office of Abraham Lincoln and William H. Herndon, was made by the Chauncey Jerome company of New Haven, Connecticut, probably around 1850. The wood near the key hole shows rub marks from many years of winding the clock. Much of the painted scene of Westminster Abbey on the glass panel in the front of the clock has chipped off, and a mouse at some point chewed a hole in the back of the base. Nevertheless, the clock, when wound for special occasions, can still run for its normal thirty hours. The Library acquired the clock as part of the Louise and Barry Taper collection in 2007.

The ticking of this clock made special appearances in Steven Spielberg's film *Lincoln* (2012), during scenes in Mary Lincoln's bedroom and Congressman Thaddeus Stevens's office.

Clock used in Abraham Lincoln and William H. Herndon's law office (24¼″ high × 17½″ wide × 8″ deep)

A Comprehensive Collection of Historical Resources

The Abraham Lincoln Presidential Library has been essential to the success of both the Papers of Abraham Lincoln and its predecessor, the Lincoln Legal Papers. Both projects have relied extensively on the original manuscript materials within the Library's collections, as well as copies of other manuscripts collected over the past century. The Library contains an incomparable assembly of manuscript collections of Lincoln's contemporaries, newspapers from throughout Illinois and beyond, and published works on all aspects of Illinois history. Together, these collections provided the basis for contextualizing documents from Lincoln's law practice in the award-winning *The Papers of Abraham Lincoln: Legal Documents and Cases* (2008). Now, the Papers of Abraham Lincoln is locating, imaging, transcribing, annotating, and publishing all documents written by or to Abraham Lincoln during his entire lifetime, including the voluminous records of his presidency. It is a monumental project that will support decades of future research and writing on Abraham Lincoln and nineteenth-century America, and once again, it will rely on the collections of the Abraham Lincoln Presidential Library.

Equally important to the source materials held by the Abraham Lincoln Presidential Library are the personnel of the Library, who make these resources available. The staff of the Lincoln Collection has provided expert advice on all aspects of Lincoln's life. Likewise, the staff of the Manuscripts, Newspapers, and Audio Visual departments aided the project by sharing their own expertise and by providing access to the sources that provide context for Lincoln documents.

The Abraham Lincoln Presidential Library is unparalleled in its resources for those studying the era of the nation's sixteenth president. At no other institution could the Papers of Abraham Lincoln access such a comprehensive collection of historical resources to interpret the documentary record of Abraham Lincoln's life and career.

Daniel W. Stowell
Director, Papers of Abraham Lincoln
Springfield, Illinois

The World's Columbian Exposition was a huge world's fair held in Chicago (May 1–October 30, 1893) to celebrate the four-hundredth anniversary of Columbus's arrival in the New World in 1492. Numerous technological innovations, agricultural products, and artistic items were displayed in enormous buildings fronting on a series of canals.

While a number of companies and businesses printed fair-related maps, this particular bird's-eye view of Chicago and the buildings of the fair, published by Knight, Leonard & Co., appears to be unique to the ALPL. (Any others in existence have not been cataloged in the vast OCLC database).

The artist, Frank (or Francis) Pezolt, born in Austria in 1843, immigrated in 1870 to the United States, where he lived in Philadelphia and Chicago, working as an artist and an engineer. He is known to have been one of the illustrators of a book on the Philadelphia Centennial Exhibition (1876), to have prepared bird's-eye view maps of Minneapolis (1891) and the Louisiana Purchase Exposition in St. Louis (1904), and to have prepared a map of Colorado for the U.S. Geological Survey (1894). Pezolt died in Chicago on July 4, 1909.

Knight, Leonard & Co.'s *Map and Birdseye View of Chicago*, 1893
(38³/8″ high × 27″ wide)

The Library's Printed and Published collection includes more than three hundred product catalogs, many for items manufactured in Illinois. Barbed wire, nursery stock, pianos, harness, agricultural equipment, furniture, and manufacturing equipment are just a few of the products offered through these catalogs. Often the catalogs include a potential buyer's notes or are connected to a business that was very important in state history.

This Deering Harvester Company catalog is one of the most unusual in the collection. Designed to look like a medallion, it was intended to appeal to visitors at the World's Columbian Exposition in Chicago in 1893. Deering's display was located with other farm machinery in the annex to the Agriculture Building. About a decade later, Deering Harvester joined with the McCormick Harvesting Machine Company and three smaller agricultural manufacturers to form the International Harvester Company.

Deering Harvester Company Columbian Exposition Souvenir Catalog, closed and open, Chicago, ca. 1892 (3½″ diameter closed)

Three trading cards publicizing patent medicines and farm products. The advertisement for Dr. C. McLane's Celebrated Liver Pills to cure sick headache includes a calendar for 1889, the year the Library was founded.

North Front Agricultural Building.

The Audio Visual Department also has a collection of approximately one hundred single-page broadsides, posters, and trading cards advertising a variety of products, especially medicinal ones.

Agriculture Building at the 1893 World's Columbian Exposition, from *Shepp's World's Fair Photographed* by James W. Shepp, p. 149

Stella Skiff Jannotta by W. J. Root, Chicago (6½″ high × 4¼″ wide)

Mary Frances Skiff, mother of Stella and Frank
(9¼″ high × 7¼″ wide)

Stella Skiff (1867–1954), the daughter of Mary Frances Coffin Skiff (1842–1918) and Vernon William Skiff (1841–1926), moved with her family from Iowa in 1889 to the Chicago area, where Stella studied music (she was a lyric soprano) with Italian-born Alfredo Antonio Jannotta (1843–1913), whom she married. Stella

Alfredo Jannotta, husband of Stella, by W. J. Root, Chicago (7″ high × 5″ wide)

and Antonio had three sons, and later Stella adopted three daughters. Despite her family responsibilities, Stella was active in the woman suffrage movement. She was a eugenicist, humanist, genealogist, writer, and supporter of some rather unusual causes. Her brother Frank Vernon Skiff (1869–1933) founded a coffee delivery service in 1899 that grew into the Jewel Tea Company and eventually the Jewel Osco grocery and drug store chain.

The Jannotta family collection, with six cubic feet of photographs and more than twenty cubic feet of manuscript materials, came to the Library in 1973.

Frank Vernon Skiff, son of Mary Frances and brother of Stella (7″ high × 5″ wide)

Virden, Illinois, native Chester Melvin Vaniman (1866–1912) was a photographer, engineer, and inventor whose particular interest was dirigibles. He made several attempts to reach the North Pole or to cross the Atlantic by dirigible (1909–1912) without success, using the airships *America* and *Akron*. The cat mascot was named "Trent" after the British steamer that rescued the crew during an aborted Atlantic crossing attempt in October 1910. Vaniman died in New Jersey on July 2, 1912, in an accident on the *Akron*.

Albert Louis Loud (1886–1940), Vaniman's brother-in-law, served as an assistant engineer on several of the earlier flight attempts. He collected numerous clippings and articles about the airships, a number of photographs, and Vaniman's patent materials. Loud's daughter-in-law gave the collection to the Library in 1974.

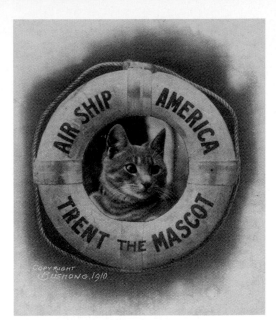

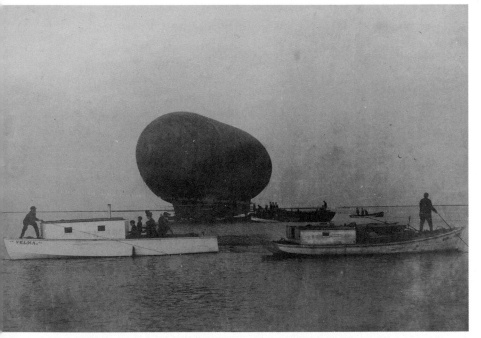

One of Melvin Vaniman's dirigibles, evidently under construction (8″ high × 10″ wide)

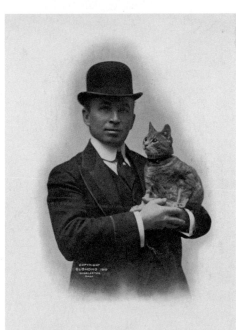

Two advertising postcards for Melvin Vaniman's airship *America*, including photos of Vaniman and the mascot, Trent, 1910 (5½″ high × 3½″ wide)

Newspapers and Boy Scouts

Over many decades, generous donations to the Abraham Lincoln Presidential Library have increased significantly the institution's important holdings. One such collection is the Dr. Leslie Keeley Papers, which former state legislator James Oughton presented to the then–Illinois State Historical Library after the Keeley Institute, a Dwight, Illinois, alcoholism-treatment center, closed in 1966. In the ensuing years, affable Mr. Oughton, a grandson of the Keeley founder, occasionally visited the Historical Library to discuss aspects of the collection. During some of those conversations, he would relate vivid anecdotes about his wife's grandfather, W. D. Boyce, a flamboyant but little-known Chicago newspaper publisher. According to Mr. Oughton, his grandfather-in-law founded the Boy Scouts of America.

Beginning with Mr. Oughton's own collection of clippings and letters, I began researching the elusive Mr. Boyce for an eventual biography, *Lone Scout*. Although a very successful businessman, he left no corporate or personal papers; thus, my main source would prove to be the Historical Library's microfilmed collection of newspapers. The *Tribune* and other Chicago dailies carried occasional stories, some front page, primarily about Boyce's marital and family problems. Most of the business information, however, came from newspapers in Ottawa, where the Boyce family resided, and Marseilles, where he owned several enterprises, including a substantial paper mill. Those small-town editors covered not only Boyce's various activities in the area and in Chicago, but also his amazing hunting expeditions in Africa, Australia, and South America. And indeed, he led the effort to establish a scouting organization in the United States, combining YMCA and other boys' programs with the group that Lord Baden-Powell founded in Great Britain in 1908. Through Boyce's efforts, the U.S. Congress in 1910 issued a charter to the Boy Scouts of America.

Janice Petterchak
Former Illinois State Historical Library director
Rochester, Illinois

Arthur D. Dubin (b. 1923), a Chicago architect, collected materials about passenger trains, especially information on Pullman sleeping cars and their operations. He wrote several books and many articles about the subject. The collection, which he sold to the Library in 1996, contains a wide variety of printed, often instructional, material and historical company ephemera, as well as photographs, blueprints, specifications for construction, broadsides, and artifacts, dating from 1829 to 1960.

Train enthusiasts are particularly fond of the small notebooks of diagrams showing the exterior paint schemes of Pullman cars for the various railroad lines. These notebooks are accompanied by a box of paint "chips" or color samples.

Diagram of paint scheme for Kansas City Southern car in paint notebook number II; paint chips of some colors used for Kansas City Southern (notebook 7³/8″ high × 10″ wide, open; paint chips 8″ high × 4″ wide)

Two broadsides (signs) formerly mounted in Pullman cars (smoking: 8¼″ high × 11″ wide; card shark: 8½″ high × 11″ wide)

6. *Mid-Nineteenth Century*

Nearly all the departments of the Library contain special treasures from the mid-nineteenth century. Abbreviations, misspellings, and punctuation appear in transcriptions of documents as they do in the originals.

———————◆———————

No one knows how many letters Abraham and Mary Lincoln exchanged during Lincoln's absences on the law circuit or in Congress. Only five of them survive (four from Abraham, one from Mary, all from 1848, during the period when Lincoln was in Congress). Lincoln burned most of the family's personal correspondence while cleaning out the house before they left for Washington, D.C. Evidently the few remaining letters were requested by neighbors as souvenirs.

This rare correspondence was purchased in March 1952.

Washington, April. 16- 1848-

Dear Mary:

In this troublesome world, we are never quite
satisfied - When you were here, I thought you hindered me some
in attending to business; but now, having nothing but business -
no variety - it has grown exceedingly tasteless to me - I hate to
sit down and direct documents, and I hate to stay in this
old room by myself - You know I told you in last sundays
letter, I was going to make a little speech during the week;
but the week has passed away without my getting a chance
to do so; and now, my interest in the subject has passed
away too - Your second and third letters have been received
since I wrote before. Dear Eddy thinks thinks father is "gone
tapila" Has any further discovery been made as to the
breaking into your grand mothers house? - If I were she, I
would not remain there alone - You mention that your
uncle John Parker is likely to be at Lexington - Dont
forget to present him my very kindest regards -
+ I went yesterday to hunt the little plaid stockings, as
you wished; but found that McKnight has quit business,
and Allen has not a single pair of the description you
give, and only one plain pair of any sort that I thought
would fit "Eddy's dear little feet" + I have a notion to

Washington, April 16—1848—

Dear Mary:

In this troublesome world, we are never quite satisfied. When you were here, I thought you hindered me some in attending to business; but now, having nothing but business—no variety—it has grown exceedingly tasteless to me. I hate to sit down and direct documents, and I hate to stay in this old room by myself. You know I told you in last sunday's letter, I was going to make a little speech during the week; but the week has passed away without my getting a chance to do so; and now my interest in the subject has passed away too. Your second and third letters have been received since I wrote before. Dear Eddy thinks father is "*gone tapila* [.]" Has any further discovery been made as to the breaking into your grand-mother's house? If I were she, I would not remain there alone. You mention that your uncle John Parker is likely to be at Lexington. Dont forget to present him my very kindest regards.

I went yesterday to hunt the little plaid stockings, as you wished; but found that McKnight has quit business, and Allen had not a single pair of the description you give, and only one plaid pair of any sort that I thought would fit "Eddy's dear little feet." I have a notion to make another trial to-morrow morning. If I could get them, I have an excellent chance of sending them. Mr. Warrick Tunstall, of St. Louis is here. He is to leave early this week, and to go by Lexington. He says he knows you, and will call to see you; and he voluntarily asked, if I had not some package to send to you.

I wish you to enjoy yourself in every possible way; but is there no danger of wounding the feelings of your good father, by being so openly intimate with the Wickliffe family?

Mrs. Broome has not removed yet; but she thinks of doing so to-morrow. All the house—or rather, all with whom you were on decided good terms—send their love to you. The others say nothing.

Very soon after you went away, I got what I think a very pretty set of shirt-bosom studs—modest little ones, jet, set in gold, only costing 50 cents a piece, or 1.50 for the whole.

Suppose you do not prefix the "Hon" to the address on your letters to me any more. I like the letters very much, but I would rather they should not have that upon them. It is not necessary, as I suppose you have thought, to have them to come free.

And you are entirely free from head-ache? That is good—good—considering it is the first spring you have been free from it since we were acquainted. I am afraid you will get so well, and fat, and young, as to be wanting to marry again. Tell Louisa I want her to watch you a little for me. Get weighed, and write me how much you weigh.

I did not get rid of the impression of that foolish dream about dear Bobby till I got your letter written the same day. What did he and Eddy think of the little letters father sent them? Dont let the blessed fellows forget father.

A day or two ago Mr. Strong, here in Congress, said to me that Matilda would visit here within two or three weeks. Suppose you write her a letter, and enclose it in one of mine; and if she comes I will deliver it to her, and if she does not, I will send it to her.

Most affectionately
A. Lincoln

Lexington May — 48 —

My Dear Husband —

You will think indeed, that old age, has set its seal, upon my humble self, that in few or none of my letters, I can remember the day of the month, I must confess it as one of my peculiarities; I feel wearied & tired enough to know that this is Saturday night, our babies are asleep, and as Aunt Maria B— is coming in for me tomorrow morning, I think the chances will be rather dull that I should answer your last letter tomorrow — I have just received a letter from Frances W. it related in an especial manner to the boy, I had desired her to send, she thinks with you(as good persons generally agree) that it would cost more than it would come to, and it might be lost on the road, I rather expect she has examined the specified articles, and thinks as Levi says, they are hard bargains — But it takes so many changes to do children, particularly in summer, that I thought it might save me a few stitches — I think I will write her a few lines this evening, directing her not to send them — She says Willie is just recovering from another spell of sickness, Mary or none of them were well — Springfield

A-1

Mary Lincoln to Abraham Lincoln, May 1848 (10″ high × 8″ wide)

Lexington May—48—

My dear Husband—

You will think indeed, that *old age,* has set *its seal,* upon my humble self, that in few or none of my letters, I can remember the day of the month, I must confess it as one of my peculiarities; I feel wearied & tired enough to know, that this is *Saturday night,* our *babies* are asleep, and as Aunt Maria B [ullock] is coming in for me tomorrow morning, I think the chances will be rather dull that I should answer your last letter tomorrow—I have just received a letter from Frances W [allace], it related in an *especial* manner to THE BOX I had desired her to send, she thinks with you (as good persons generally agree) that it would cost more than it would come to, and it might be lost on the road, I rather expect she has examined the specified articles, and thinks as *Levi* says, they are *hard bargains*—But it takes so many changes to do children, particularly in summer, that I thought it might save me a few stitches—I think I will write her a few lines this evening, directing her not to send them—She says Willie is just recovering from another spell of sickness, Mary or none of them were well—Springfield she reports as dull as usual. Uncle S [amuel Todd] was to leave there on yesterday for Ky—Our little Eddy, has recovered from his little spell of sickness—Dear boy, I must tell you a story about him—Boby in his wanderings to day, came across in a yard, a little kitten, *your hobby,* he says he asked a man for it, he brought it triumphantly to the house, so soon as Eddy, spied it—his *tenderness,* broke forth, he made them bring it *water,* fed it with bread himself, with his *own dear hands,* he was a delighted little creature over it, in the midst of his happiness Ma came in, she you must know dislikes the whole cat race, I thought in a very unfeeling manner, she ordered the servant near, to throw it out, which, of *course,* was done, Ed—screaming & protesting loudly against the proceeding, *she* never appeared to mind his screams, which were long & loud, I assure you—Tis unusual for her *now a days,* to do any thing quite so striking, she is very obliging & accommodating, but if she thought any of us, were on her hands again, I believe she would be *worse* than ever—In the next moment she appeared in a good humor, I know she did not intend to offend me. By the way, she has just sent me up a glass of ice cream, for which this warm evening, I am duly grateful. The country is so delightful I am going to spend two or three weeks out there, it will doubtless benefit the children—Grandma has received a letter from Uncle James Parker of Miss [ouri] saying he & his family would be up by the twenty fifth of June, would remain here some little time & go on to Philadelphia to take their oldest daughter there to school, I believe it would be a good chance for me to pack up & accompany them—You know I am so fond of *sightseeing,* & I did not get to New York or Boston, or travel the lake route—But perhaps, dear husband, like the *irresistible Col Mc,* cannot do without his wife next winter, and must needs take her with him again—I expect you would cry aloud against it—How much, I wish instead of writing, *we* were together this evening, I feel very sad away from you—Ma & myself rode out to Mr Bell's splendid place this afternoon, to return a call, the house and grounds are magnificent, Frances W. would *have died* over their rare exotics—It is growing late, these summer eves are short, I expect my long *scrawls,* for truly such they are, weary you greatly—if you come on in July or August *I* will take you to the springs—*Patty Webb's* school in S[helbyville] closes the first of July, I expect *Mr Webb* will come for her. I must go down about that time & carry on quite a flirtation, you know *we,* always had a *penchant* that way. ~~With love~~ I must bid you good night—Do not fear the children, have forgotten you, I was only jesting—Even E[ddy's] eyes brighten at the mention of your name—My love to all—

Truly yours
M L—

Before They Were Famous

When Stephen A. Douglas and Abraham Lincoln debated the great national issues in the 1858 senatorial contest, they unknowingly set a standard to which all political debates are compared and also contributed to a national frenzy for collecting autographs of famous people. The debates allowed Abraham Lincoln to be introduced to a national audience where Stephen A. Douglas had long held center stage. The debates were a prelude to the 1860 presidential contest where both candidates continued the national debate on slavery. But what were these individuals like before they were famous?

Among the rich Library holdings is a page from a young Abraham Lincoln's sum book and a complete sum book of Stephen A. Douglas. Lincoln's page shows an emphasis on math and solving long division problems. Writing exercises predominate in Douglas's book, especially various attempts at bold signatures. The common tie to both is their interest in doggerel.

Douglas reflects a youthful morbid curiosity with death:

> O could we step into the grave
> And lift the coffin lid
> And look upon the greedy worms
> That eat away the dead.

Lincoln is more playful:

> Abraham Lincoln is my name
> And with my pen I wrote the same
> I wrote in both haste and speed
> And left it here for fools to read.

Thomas F. Schwartz
Director, Herbert Hoover Presidential Library and Museum
West Branch, Iowa

Stephen A. Douglas (1813–1861), born in Vermont, practiced some law but mostly politics in Illinois, where he moved in 1833. Among other posts he served as state legislator, register of the land office, Illinois secretary of state, judge, congressman, and U.S. senator (1847–1861). He pushed the passage of the Compromise of 1850 and disturbed the precarious peace of the country by introducing and advocating the Kansas-Nebraska Bill in 1854. In order to open the way for a transcontinental railroad, Douglas wanted to see Kansas and Nebraska organized as two separate territories with "popular sovereignty," the option for the people of each territory to choose whether they wanted to have slavery or not.

The concept had been introduced by Lewis Cass in 1848, but Douglas's advocacy of it caused special problems. Both territories were in a part of the original Louisiana Purchase, which, according to the Missouri Compromise (1820), was never to have slaves. In essence, the Kansas-Nebraska Act abolished the Missouri Compromise, creating great upheaval in the North among people who did not want to see slavery expand. The prospective spread of slavery in the territories prompted Abraham Lincoln to return to politics and in 1858 to challenge Douglas (unsuccessfully) for his senate seat.

This letter from Douglas to Illinois lawyer and former state legislator James W. Singleton (1811–1892) presents Douglas's view of the importance of popular sovereignty as "salvation for the Democratic party."

———————◆———————

In 1860 Douglas was the Northern Democrats' candidate in a four-way presidential election won by Lincoln. Douglas died, probably of typhoid fever, June 3, 1861. Singleton served in Congress from Illinois (1879–1883).

Acquisitions information for this letter is incomplete, but the missive may have arrived at the Library in 1963 or 1964. The letter is missing all of Douglas's signature except for the tips of the tallest letters because the page separated on a fold and the bottom part is missing.

Stephen A. Douglas

Letter from Stephen A. Douglas to James W. Singleton,
March 31, 1859 (9½″ high × 7½″ wide, p. 1; 5″ high × 7½″ wide, p. 2)
[p. 2 not shown]

Washington, March 31, 1859

My dear Sir,

Your kind letter of the 20th ult. arrived during the last days of the session when the pressure of business was so great that I was unable promptly to attend to my correspondence. I have already sent you a copy of my speech, made after your letter was written, but before it was received, from which you will perceive a striking coincidence of the identity of our views. We must meet the issue boldly which has been presented to us by the Interventionists from the north and from the South and maintain with firmness a strict adherence to the doctrine of popular sovereignty and non intervention by Congress with slavery in the Territories as well as in the states. There is no other salvation for the Democratic party. I do not intend to make peace with my enemies, nor to make a concession of one iota of principle, believing that I am right in the position I have taken, and that neither can the Union be preserved or the Democratic party maintained upon any other basis. I agree with you fully in regard to the necessity of thorough organization of our friends preparatory to the great battle at Charleston. With a bold, honest platform, avowing our principles in unequivocal language, and a candidate standing upon that platform who is thoroughly identified with it, and whose past gives assurance that he will honestly carry it out, our success is certain. The time has arrived when our friends should prepare for energetic organized action.

I am, very truly,
Your friend,
[signature missing]

On May 24, 1861, Colonel Elmer Ellsworth (1837–1861) of the New York Fire Zouaves (11th New York Infantry) and a few of his men crossed the Potomac River to Alexandria, Virginia. Their first stop was the Marshall House, a hotel where a Confederate flag had been flying to the annoyance of many U.S. government officials who could see it from Washington, D.C. As Ellsworth descended the stairs with the confiscated flag, James W. Jackson, the hotel proprietor, shot and killed Ellsworth. Jackson was, in turn, shot and bayoneted by Corporal Francis E. Brownell.

Ellsworth, a former law student of Abraham Lincoln, was very close to the president's entire family. He had also gained national renown as the leader of the U.S. Zouave Cadets, a military drill team based in Chicago that gave performances around the country in 1860. His death was a shock to the North, and mourning for the martyr Ellsworth was widespread. Composers memorialized Ellsworth in at least sixteen funeral marches, of which the Library owns six examples.

Lithograph, "Death of Ellsworth," labeled with the names of the principal characters, after a painting by Chappel (New York: Johnson, Fry, and Co.)

TO THE FAMILY

Of the Hero whose devoted life and death

These pages commemorate,

Bowed in sorrow at his loss,

But

Covered with the glory he has bequeathed them,

By his fearless self-sacrifice

On the altar of his Country,

This memorial

Of the fame which lives eternally in his death

IS RESPECTFULLY DEDICATED.

Dedication page of *Life of James W. Jackson Who Killed Col. Ellsworth*, 1862
(9″ high × 5¾″ wide, closed)

In the South, however, the hotel keeper James Jackson was the hero, venerated as a martyr for the Confederacy. The *Life of James W. Jackson Who Killed Col. Ellsworth*, printed in the Confederacy in 1862, glorified Jackson, and lambasted Ellsworth, Abraham Lincoln, and all Northerners in general.

The Library's copy, according to a penciled note, was "found in Rebel Camp at Chickahominy" by N. Wall of the 2nd Rhode Island Infantry. How it then got to the Library is not clear.

Civil War materials were among the earliest to be collected by the Library, and they continue to be actively acquired through donation, and purchase when possible. These items, in addition to printed books, include letters from the army (and a lesser number written from the home front to soldiers), diaries, commissions, regimental records, hand-drawn maps, patriotic stationery, memoirs, reminiscences, and pension records. At present the Manuscripts Department holds at least one thousand such collections, containing anywhere from a single item to more than twenty boxes of material. While the majority of the materials are from Illinois, the Civil War's connection to Lincoln permits the Library to accept donated materials from other states, and even occasionally the former Confederacy.

———————◆———————

Although this is a very ordinary-looking letter, this missive from Asher Miller is unusually informative and represents the hundreds of Civil War letters to be found in the Library's collections. Miller (1825–1906), a native of New York, was a Rockford, Illinois, stone mason when he enlisted in the 74th Illinois Infantry as a musician, apparently a fifer, in 1862. Musicians were expected to serve as stretcher bearers and nurses in time of battle, especially earlier in the war. Miller was caring for wounded soldiers from the Battle of Murfreesboro

(or Stones River) when he wrote this letter. The recipients, George and Eliza Miller, ages about seventeen and twelve respectively, were the children of Miller's brother Anson S. Miller, a Rockford lawyer, postmaster, county judge, and state legislator. The letter is quite graphic in its descriptions of wounds and hospitals. Written to take advantage of every fragment of the paper, the letter has no paragraphs or skipped lines.

Hospital at 4 miles from Murfreesboro Jan 15, 1863 My Dear Nephew Your kind Letter of Dec 21st come to hand Jan 12th and with it five others Two from Lottie one from Lyman & Lucina one from Mr Rowlee and one from Brother Cyrus making me a feast of good news and the greatest trouble was to know which to open and read first. The letters have all been read and reread carefully and with great Satisfaction to me for which I shall ever feel gratefue to those whose love has followed me in all my toilsome March and whose attachment for me remains though Separated by many miles. Asher b. and Adam H. Davis of Capt Sloans company are with me at the hospital helping take care of the wounded only three of the 7th are at this hospital Capt Ward of Co K. Henry Heagle Sergeant in Co. F & private Thayer of Co H the rest have died or have been removed to Nashville Charles M. Stevens of Pecatonica Nephew of Thatcher Blake of Rockford. Was buried 13th The Number of his grave is 31 Asher b and myself attended him until he died and carried him to his grave & buried him by the side of two others. Many die in the hospital who appear only slightly wounded when first brought in. A Minnie bullet tears a great hole so that you could run your thumb right down into the wound and needs to be watched carefully to have it heal Most of the men who are Struck by fragments of Shells are killed instantly Sometimes a Spent piece will only lame a man but usually mangle So bad that Mortification ends the mans life As Soon as We See a man begin to tremble all through his body We know that the wound is Striking to his Vitals and he cannot live long. Could you have Spent a Single hour at the hospital you would have Seen enough to last you a lifetime. Just imagine the Court House at Rockford Stripped of its benches and fille with wounded men as thick as they could lay then the whole yard covered with hospital tents full of wounded and you would have but a faint Idea of the horrors of War. our Building which is a large Sized planters house with the tents was said at one time to contain eight hundred men Now there is not over two hundred men for as fast as they were able they were sent to Nashville where they will be treated at the General Hospital and as soon as able Sent home to their families

Letter from Asher Miller to his nephew George Miller and niece Eliza Miller, January 15, 1863
(9¾″ high × 7¾″ wide) [side 2 not pictured]

Hospital 4 miles from Murfreesboro Jan 15th, 1863 My Dear Nephew Your Kind Letter of Dec 21st come to hand Jan 12th and with it five others Two from Lottie one from Lyman & Lucina one from Mrs Rowlee and one from Brother Cyrus making me a feast of good news and the greatest trouble was to know which to open and read first. The letters have all been read and reread carefully and with great Satisfaction to me for which I shall ever feel grateful to those whose love has followed me in all my toilsome march and whose attachment for me remains though Seporated by many miles. Asher G. and Adam H. Davis of Capt Sloans Company are with me at the hospital helping take care of the wounded only three of the 74th are at this hospital Capt Ward of Co K. Henry Heagle Sergeant in Co. F & private Thayer of Co H the rest have died or have been removed to Nashville Charles M. Stevens of Pecatonic nephew of Thatcher Blake of Rockford was buried 13th The number of his grave is 31 Asher G and myself attended him until he died and carried him to his grave & buried him by the side of two others. Many die in the hospital who appear only Slightly wounded when first brought in. A Minnie bullet tears a great hole so that you could run your thumb right down into the wound and needs to be watched carefully to have it heal Most of the men who are Struck by fragments of Shells are killed instantly Sometimes a Spent pice will only lame a man but usually mangle So bad that mortification ends the mans life As Soon as we See a man begin to tremble all through his body we know that the wound is Striking to his vitals and he cannot live long. Could you have spent a Single hour at the hospital You would have Seen enough to last you a lifetime. Just imagine the Court House at Rockford Stripped of its benches and filled with wounded men as thick as they could lay then the whole yard covered with hospital tents full of wounded and you would have but a faint Idea of the horrors of War. our Building which is a large Sized planters house with the tents was said at one time to contain eight hundred men. Now there is not over two hundred men for as fast as they were able they were sent to Nashville where they will be treated at the General Hospital and as soon as able Sent home to their families [p. 2] The Weather today is Very rainy and it has been raining for the past two days and when rain comes here it just pours right down like a thunder Storm in July. Stewards creek a Stream close by the hospital is raging high and has Swept away the trestle Bridge on the pike The creek is about as large as the Kishwaukie. I have been to Murfreesboro once Since the Battle it is a pretty town of Some twenty five hundred inhabitants before the war it had four thousand The Court House is an ornament to the town It is of brick two Stories high with a fine Spire It is now the office of the Provost Marshal. Most of the Army are beyond the town awaiting further orders. All the boys at Camp are well For a full account of the Battle I refer you to the Chicago papers for we do not know how to make any accurate Statement with regard to the number of killed and Wounded We hardly see a newspaper except from home I got the Democrat you sent me and hope to receive more from you. and now I must write Eliza a few lines. write often and accept the high regard and love of your affectionate uncle Asher Miller

Dear Eliza That nice little letter of yours enclosed in your Brother George came Safely to hand for which I thank you and am rejoiced that you are gaining in health so fast. Now what do you suppose your uncle Asher has to do at the hospital Last night I held the light for the Surgeon to cut off a Soldiers left arm close to his Shoulder How would it look to you to See us lay a man on a large Square table in the centre of the room and with bright knives & Saw take his arm off then hook up the arteries and tie them and then Sew the Skin together and lay him down on his cot again. I took his arm and carried it out. He is a fine looking man by the name of James Manly 38th Indiana Vol and is quite comfortable to day. I have written quite a number of letters for Soldiers to their friends and am glad that I can be useful in alleviating the Sufferings of the poor wounded men. Sad is condition of the Suffering Soldier away from home and kindred and when we bury them no father Mother Brother or Sister Shed a tear over their graves many hearts must bleed on account of this War When your Father writes to me you must write Tell your mother to Kiss you for Me and accept the love of your uncle Asher Miller

Two Treasures

The Library holds two particular treasures that brilliantly illuminate a subject of special interest to me: the intertwined worlds of Civil War politics and religion. The manuscript diary of Leonard F. Smith, an earnest abolitionist and Methodist minister of central Illinois, reveals a young man who was fired with excitement by the early Republican party and who traveled a switchback of emotions during the war years. Wearing his heart on his sleeve, Smith worked tirelessly for his vision of the Union, in 1860 championing Lincoln against the Democrats (a "noisy dirty ignorant rabble") and seeking in wartime to neutralize the anti-administration "Copperheads" who were especially strong in the lower reaches of the state. He grieved over divided churches and the disloyalty of "old hard shell" types who had let "the Devil & politics lead [them] from the right" and wanted to perpetuate slavery. "It is some consolation," he reflected, "that they are old and shortly will die & then better things will be accomplished."

Among the Copperheads whom Smith rebuked were subscribers to a monthly periodical, *The Old Guard*. Launched by Charles Chauncey Burr in 1863 to castigate the Lincoln administration and claiming devotion to "the principles of 1776 and 1787," the magazine was a mouthpiece for the deep racial antipathies of those white Northerners who lamented what Burr called "a vulgar and brutal quarrel about negroes." Burr's polemics, literary flair, and conservative theology—casting the Lincoln administration as bloodthirsty, autocratic, diabolical, and morally bankrupt—gave Peace Democrats a religious argument for slavery, white racial supremacy, and resistance to the draft. *The Old Guard*, as an ethical counterpoint to Leonard Smith's Unionist diary, makes compelling, if dismal, reading and is an invaluable key for unlocking the Copperhead mind.

Richard Carwardine
President, Corpus Christi College, Oxford, England

During the Civil War, supporters of the United States Sanitary Commission raised funds in many ways to meet the needs of sick and wounded Union soldiers. Sanitary fairs, which lasted for several weeks, typically displayed and sold artistic and other items, provided entertainment, and purveyed refreshments to raise funds. These fairs often had a daily fair newspaper as well. (The Library's collection contains several of these papers.)

Editor Joseph Kirkland—a Civil War veteran—and other supporters of the Commission at Tilton, Vermilion County, Illinois, began a monthly literary paper to raise funds for the Commission. The four-page paper, called *The Prairie Chicken*, was published from October 1, 1864, to September 1, 1865, and printed in Champaign. It had a circulation of five hundred at a subscription rate for the entire twelve issues of one dollar. The Library's copy, one of the few remaining complete runs of the paper, was received from the Onondaga Historical Association of Syracuse, New York, in 1954.

The Prairie Chicken contained poetry, short stories, essays, editorials, recipes, soldiers' letters, foreign correspondence, humor, and other miscellany, but no illustrations. Several of the pieces give an interesting perspective on the home front during the war. Because most of the printing costs and paper were donated, the publication raised $300 for the Sanitary Commission.

First page of *The Prairie Chicken*, March 1, 1865 (12″ high × 9″ wide)

Still Amazing

I have worked in the Manuscript Section of the Library for over forty years. While some would think remaining in one place wearisome, I have not found that to be the case. I am still amazed by the breadth and depth of the Library's holdings. New collections arrive, and both researchers and staff discover new information in long-held collections. The new questions researchers ask keep older collections as relevant as new ones.

Topics come in cycles, like fashion, so people working on similar projects find each other in our reading room. Friendships and collaborations can begin here. I have been privileged to play a small part in some of these interactions. Another area of personal satisfaction has been working with the many eminent scholars drawn to the Library by the quality of its holdings.

Just when we think there could not be any material on a topic in the holdings, we are surprised at what we find. For example, a student researched World War II prison camps run by the Japanese. What did the Library have for this project? The researcher and I found detailed maps and information on Allied troop placement in the Pacific in the papers of an admiral and an army doctor stationed in the Pacific. These finds made good context for the project and broadened my knowledge of these collections.

Researchers have found material that appeals to all ages and interests. The Monticello College Records were used for background for a children's book on the Underground Railroad. Students from several schools visit the library yearly to do research for their own projects and for History Day entries. Others find family and community history, plays, poetry, and organizational records of many kinds.

One of the things I enjoy most about working here is the wide range of materials available. Each collection has its own story to tell. Some of them are so surprising that no fiction writer could think up these stories. Just this morning we were reading a description of fleas bothering a Civil War soldier's sleep. While I knew in general that fleas could be a problem in Civil War camps, this soldier's description made me feel itchy.

Projects both large and small are researched in our holdings. Often there is considerable time between the beginning and the end of projects. I am very happy to hear when a researcher's work is published. This is one of the unspoken rewards of working here.

Cheryl Schnirring
ALPL Manuscripts Curator

Born in Scotland, James Muirison Taylor (1839–1921) came to the United States with his older sister and younger brother when he was thirteen. He attended and taught school as well as did farm work in Lake County, Illinois, before the war. On August 1, 1862, Taylor enlisted in Company C, 96th Illinois Infantry, was soon elected corporal, and later was promoted to sergeant. Wounded in action at Rocky Face Ridge, Georgia, on May 9, 1864, Taylor had to have his right arm amputated on May 27 because of arterial bleeding. After the war Taylor became a lawyer, married, and settled in Taylorville, Illinois. His Civil War diaries and letters, as well as many post-war family papers, were given to the Library by his great-grandson in 2006–2007.

James M. Taylor in his later years

Pages from James M. Taylor's 1864 Civil War diary showing his right-handed penmanship before he was wounded (May 7–8) and his early left-handed efforts after his amputation (May 27–28) (6″ high × 6″ wide, open)

SATURDAY, MAY 7, 1864.

Rev at 3½ H G. [Health good] Weather very hot. We marched about 5 and after the Brigade came along we took our place in it and advanced towards Tunnel Hill there was a good deal of discussion among the boys whether we had ever traveled the road before and after a while we came to a point which we knew. We found the road through the woods badly blocked up with trees newly failed [felled] but we cut our way past them and filed to the left in the hollow below our old position on the hill and came on to a high ridge and advanced in line of Battle We passed over one steep hill after the other and without molestation althouh the ground was Such the [they] might have cut us all to pieces about 11 we were thrown into the the [sic] front on the Right and advanced on Tunnel Hill but as good luck would have it there was no troops there so we were all safe the 96 being the first in We Spent the rest of the afternoon resting after having built [?] some Some breast works No mail for us

SUNDAY, MAY 8, 1864.

H G Rev at 3½, while on our Right some of the Troops had been up for two hours before. The morning very pleasant only the fog lay in the valleys till the sun got well up. We fell in about 7 ½ and lay till about 9 when we advanced down the hill till near the R-R where lay the rest of the day. We being in the rear line of battle. Our first line and the Skirmishers being down in the valley down in front. We spent the most of the time lying in the shade, or watching the rebs on the face on top of Rocky faced Ridge. The weather being very

warm and oppressive but toward night it got a little cooler and clouded up a little. I went down to the R-R and saw our line of Skirmishers laying out in the open field and our first line of battle playing corner ball and a few minutes later I saw the Skirmishers with tents up. The coolest work I ever saw. Howard appears to like to keep the first day of the week. And I am glad to see it. Heavy Skirmishing in the morning died away till about 3 ½ O clock when it became much hotter again and we opened on them with shells [?] and drove them out of their holes and our Skirmishers advanced clear into the grass untill they ran [?] through We returned after [?] [illegible] to our old place behind the breastworks. Mail came in 1 letter from Mary she is sick

FRIDAY, MAY 27, 1864.

H G but quite weak from suffering so much pain. did not bleed any during the night but it commenced while Dr Sample was talking with me he fastened the tourniquet took off the dressing, washed of my arm and sent for the Surgeon in Charge After a good deal of examination He allowed there was some hemorrage and after a while they carried me down stairs and amputated my arm I suffered no pain and lost no blood

SATURDAY, MAY 28, 1864.

H G but feel quite weak from the pain I had suffered and the effects of the Amputation. Mrs Ranney wrote two letters, one to each of my sisters for me and told James Baters folks I wanted about 20 Dollars in money did not open my arm today at all to dress it.

During the Civil War, paperwork flourished in all military and governmental departments, most of which had to be copied by hand in duplicate or triplicate. Lists, requisitions, reports, and other records can be found in a number of the Library's Civil War collections.

Each soldier was supposed to have an individual "Descriptive Roll." It contained important background information about his personal identifying characteristics, his enlistment, his clothing account, any medical records, and information about when he was last paid and how much was due him. If a soldier was sent to the hospital, his descriptive roll was supposed to go with him. If it did not, delays could result, including failure to get a medical furlough or discharge.

Such a descriptive roll survives in the Library collection for Moses Milton Bean (1841–1912), a private in Company A, 45th Illinois Infantry. A native of Maine who had moved to Illinois in his late teens, Bean was living in Iowa when he enlisted in this Illinois regiment in December 1861.

Bean's two hernias, incurred at Fort Donelson in February 1862, worsened at the Battle of Shiloh (Pittsburg Landing) in April 1862, where he also had his left fore-finger shot off. Apparently his injuries resulted in a furlough to his parents' home in Lanark, Carroll County, Illinois—where this copy of his roll was made—and then in a medical discharge from the army on November 2, 1863. He moved back to Iowa, where he married in 1867 and eventually operated a fish market.

Bean's descriptive roll is part of the papers of John Eugene Smith, colonel of the 45th Illinois Infantry.

Descriptive roll for Moses M. Bean, 45th Illinois Infantry (6½″ high × 15″ wide)

{Copy of origional}

Descriptive Roll & Acc't of Pay & Clothing of Moses M. Bean

Name	Rank	Years of Age	Eyes	Hair	Complexion	Hight	Where Born	Enlisted	Last Paid	Remarks
Moses M. Bean	Private	21	Blue	fair	Light	5 ft 9½ in	Maine—Andover	Dec. 16th 1861—at Chicago—by A. Polsgrove —3 years	By Major Gatsur— Dec 31st	Wounded in action at Pittsburg, Tenn. Left Fore finger Shot off. Is ruptured in Two places caused by a fall at Ft Donelson & increased at Pittsburg action He cannot endure marching & has applied to Adjutant Frohock for an honorable discharge after May 12th/62

Amount of clothing drawn–1 Jacket 4.75–1 pair Trowsers 4.25–2 pr. Drawers 2.50 –2 pr Shoes 4.25

2 prs. stockings 1.60–1 Cap 1.75–1 Blanket 2.95–1 Rubber Blanket 1.25 –1 overcoat 9.50—2 shirts 2.50

Lost in action at Pittsburgh,–1 overcoat–1 Shirt,–1 Blanket–2 pr Socks, –1 Rubber Blanket

Clothing allowance	$12.00
} Wages due Soldier	44.16
	15.55
	71.71
Clothing drawn at different Times	33.29
	38.42
Due Suttler H. H. Davis	2.00
Due Soldier April 12th/62	$36.42

added May 12th

The above named Private required Medical attention until May 12th/62—May 12th Wages Due Soldier

Clothing allowance

$13.00	
3.60	
16.60	16.60
Due soldier May 12th	$53.82

I hereby Certify that this is a Correct Copy of the origional
Descriptive Roll & acc't of Pay & Clothing of Moses M. Bean, of Company
"A" 45th Reg't Illinois Volunters

J Haller M.D.
Medical attendent

Lanark Carroll Co, Ills. June 4th 1862

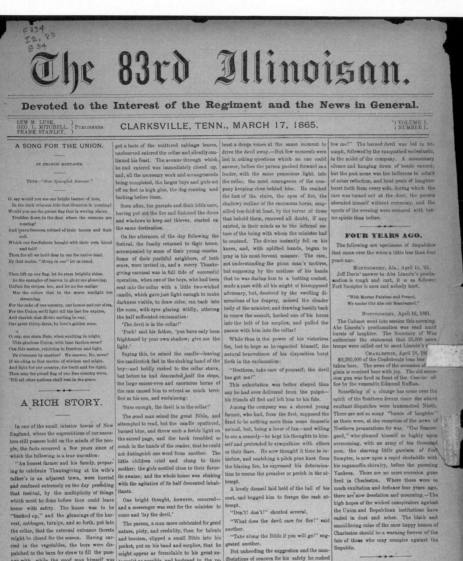

The 83rd Illinoisan, March 17, 1865 (14″ high × 11″ wide, closed)

This Civil War regimental newspaper, carrying regimental and general news, was published in Clarksville, Tennessee, where the 83rd Illinois Infantry was stationed, in the closing months of the Civil War. The eleven issues ran from March 17 to May 26, 1865. A notice in the May 26 issue indicated that it would be the final edition due to lack of paper. In fact, all the issues were printed on wood pulp paper and are now fragile and crumbling.

The three publisher/editors were young men of Company C. Lemuel M. Lusk and George L. Mitchell, both printers from Monmouth, Illinois, were eighteen when they enlisted as privates at the regiment's formation in July 1862 and served until it was mustered out on June 26, 1865. Frank Stanley, a Rio, Illinois, farmer, was twenty when he enlisted in the regiment on January 31, 1865. Because he had enlisted so much later, he was transferred to Company D, 61st Illinois Infantry when the rest of the regiment was mustered out and served until September 8, 1865.

During the Civil War, regular newspapers were published as paper, equipment, and staff permitted. Atlanta's *Southern Confederacy* was established in 1859, even before secession, and with the threat to Atlanta in the summer of 1864, moved to Macon, Georgia, where publication continued until February 1865. *The War Eagle*, a Union paper, was published in Columbus, Kentucky, on a weekly or twice-weekly basis by H. L. Goodall in 1863–1864. The Library has five issues. *The Camp Kettle*, the regimental newspaper of the 100th Pennsylvania Infantry (the "Roundhead Regiment"), commanded by Colonel Daniel Leasure, was published as often as possible. The November 4, 1861, issue was dated from the steamer *Ocean Queen*. Another, later, regimental paper, published every Saturday in Athens, Alabama, by C. H. Lamoreaux, served the 2nd Iowa Infantry in 1864. Though its title suggests otherwise, *The Free South*, published in Beaufort, South Carolina, in 1863–1864, was a weekly Union paper.

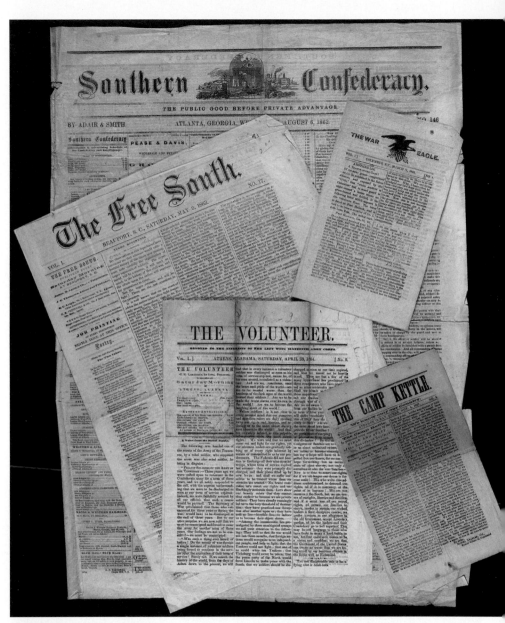

Civil War newspapers (clockwise from the rear): *Southern Confederacy*, August 6, 1862 (21¾" high × 16" wide); *The War Eagle*, March 11, 1863 (7¾" high × 4½" wide); *The Camp Kettle*, November 4, 1861 (8" high × 5" wide); *The Volunteer*, April 23, 1864 (10½" high × 8" wide); and *The Free South*, May 2, 1863 (15" high × 11¼" wide)

Ring given by John Wilkes Booth to Isabel Sumner in 1864 (¾″ diameter excluding jewels)

Inscription inside band of Booth's ring

The conquest of any woman's heart was allegedly easy for matinee idol actor John Wilkes Booth (1838–1865). Isabel Sumner (1847–1927), the only one of these young women whose correspondence from Booth survives, met Booth in the late spring of 1864 in Boston, where he was starring for about a month. Because Isabel was only seventeen and her parents would doubtless have disapproved of a relationship with a flamboyant actor, Booth addressed his six letters during that summer to Isabel at the Boston post office. Those letters are now in the Library's Lincoln collection.

In addition to those letters, Booth also gave Isabel several gifts. One of them, this lovely gold ring, inscribed J.W.B to I.S. inside, is set with a pearl in a silver four-petal outline.

Unlike other Booth correspondents, Isabel did not destroy his letters after he had assassinated Abraham Lincoln. Many years after Isabel died, her daughter made the Booth materials known publicly. The Library received them as part of the Louise and Barry Taper Collection in May 2007.

After the sudden death of his father, Robert T. Lincoln, the deceased president's oldest son, sent this brief telegram to his uncle Clark Moulton Smith (1820–1885). Smith, the husband of Mary Lincoln's sister Ann, was a Springfield, Illinois, dry goods merchant who happened to be on a buying trip in New York at the time Lincoln was assassinated and thus was the nearest family member who could help in the crisis. Presumably before he left New York, Smith ordered thirty thousand yards of black crepe, fabric that he would sell at cost to those in Springfield who wished to express their mourning for Lincoln by decorating their homes and businesses, as was the custom at the time.

The Library purchased this telegram draft, which is in Robert's handwriting, in 1954.

Robert T. Lincoln to Clark M. Smith, telegram, April 15, 1865
(7¾″ high × 5⁹/16″ wide)

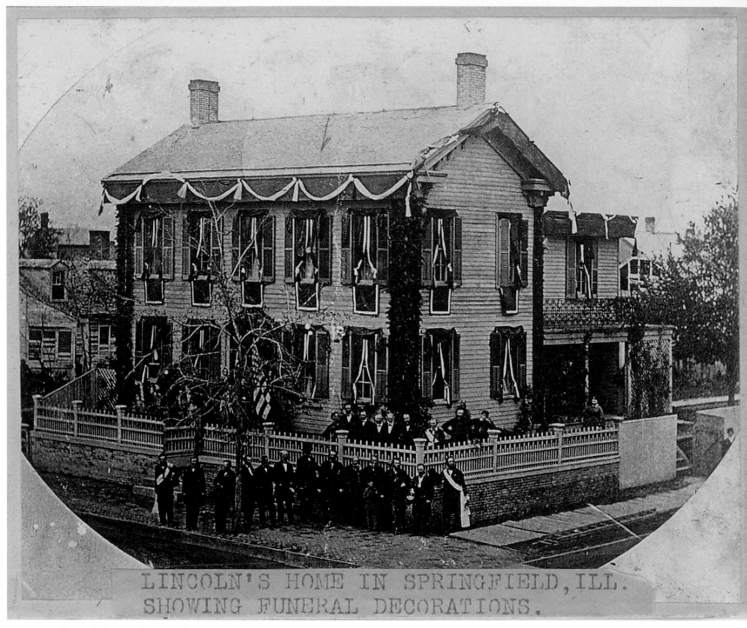

LINCOLN'S HOME IN SPRINGFIELD, ILL.
SHOWING FUNERAL DECORATIONS.

Lincoln home decorated in mourning

Soon after Abraham Lincoln's death, Robert T. Lincoln also telegraphed David Davis, a close friend of the family. Davis (1815–1886) moved in 1835 to Illinois, where he became a lawyer in Bloomington, and eventually the judge of Illinois' Eighth Judicial Circuit (1848–1862). For many years Davis was a close associate of Abraham Lincoln and was instrumental in Lincoln's election to the presidency. Lincoln appointed Davis an associate justice of the U.S. Supreme Court (1862–1877), but Davis finished his political career as a U.S. senator from Illinois (1877–1883).

In 1838 he married Sarah Woodruff Walker (1814–1879) of Lenox, Massachusetts. They had a son, George Perrin Davis (1842–1917), and a daughter, Sarah Worthington Davis (1852–1934), to whom Sarah addressed her letter of April 16, 1865, as she and her husband were visiting in Chicago at the time of Lincoln's assassination.

Clark M. Smith

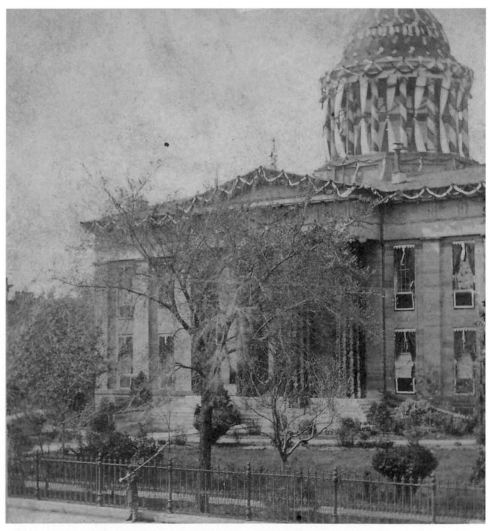

Old State Capitol draped in mourning

My Dear children

I add but a word —
— I start at 5 for Washington.
& I hope our lives may all
be preserved during our
absence from each
other — Love one another.
& be kind & courteous
to all —
This terrible tragedy
prostrates me
Your affectionate
father.
D Davis

Chicago April 15th 1865

My dear children — [Bloomington]
Your Father has just gone
to church with Mrs Bishop and Sarah.
Mr Bishop who has a slight attack of
Rheumatism, stays at home with me — and
the dear baby is just asleep in the arms
of his nurse — I have felt rather worn for
a day or two — and the dreadful news
from Washington has not steadied my
nerves — We can hardly realize that it is
true, so suddenly it has fallen on our
ears — Robert Lincoln telegraphed to
your Father yesterday to come on at once
and look after the affairs of his Father,
and to night he expects to start for
Washington — and may be gone some
days — I feel reluctant to have him go,
and yet he cannot refuse the family
of Mrs Lincoln, in this hour of trial
and anguish — the sorrow seems

Letter from Sarah and David Davis (Chicago, Illinois) to their children (Bloomington, Illinois), April 16, 1865
(8″ high × 10″ wide, open) [pp. 2 and 3 not shown]

[upside down on top of first page]

Please tell me in reply to this letter—the Size of your sleeping room—I may perhaps find a carpet for it—and may not—Direct letters to me to care of N.W Bishop—78. Dearborn Street=

[right side up]

Chicago April 16th 1865.

My dear Children—
Your Father has just gone to Church with Mrs Bishop and Lizzy—Mr Bishop (who has a slight attack of Rheumatism) stays at home with me—and the dear baby is just asleep in the arms of his nurse—I have felt rather worn for a day or two—and the dreadful news from Washington has not steadied my nerves—We can hardly realise that it is true, so suddenly it has fallen on our ears—Robert Lincoln telegraphed to your Father yesterday, to come on at once and look after the affairs of his Father, and to night he expects to start for Washington—and may be gone some days—I feel reluctant to have him go, and yet he cannot refuse the family of Mr Lincoln, in this hour of trial and anguish—The sorrow seems very general here—Gov Seward seems in a critical state as well as his Son—but I hope he may be spared to his Country—I am constantly reminded of the bloody scenes of the French Revolution—and feel that we are again plunged in a sea of darkness just as we thought the day was breaking—May God in mercy remove the clouds that surround us—The principal streets here are draped in mourning—yesterday was the day appointed for the laying of the Corner Stone of the building for the Sanitary Fair—This was of course postponed—as also the opening of the new Opera House, which was to take place tomorrow.

I have been invited to visit at Judge Drummond's one day this week I dont know yet what day—I have been unable to accomplish much in the way of business as yet—and probably shall not come home till late this week—I think Lizzy will accompany me—Will write again when I decide on the day, that you may meet us at the Depot—

I trust that you are all well, and that we may get a letter to day from some of you—Write me on receipt of this—Am anxious to hear how John Robinson is—

How are you getting on with the out of door work? The weather here is quite cool and vegetation far behind ours—

Did Addie get Catharine Walsh to help her about cleaning? But baby has just waked, and as I am just now alone with him I must take him up unless I can coax him with his rubber doll to lie a little longer—

So with love to all in which all join—I am as ever—

> your affectionate mother,
> Sarah W. Davis—

P.S. I am having a pleasant visit—Cousin Lucy left Wednesday evening. I hope to hear soon of her safe arrival.

My Dear children
I add but a word—I start at 5 for Washington. I hope our lives may all be preserved during our absence from each other—Love one another & be kind & courteous to all—
This terrible tragedy prostrates me
> Your affectionate father.
> D Davis

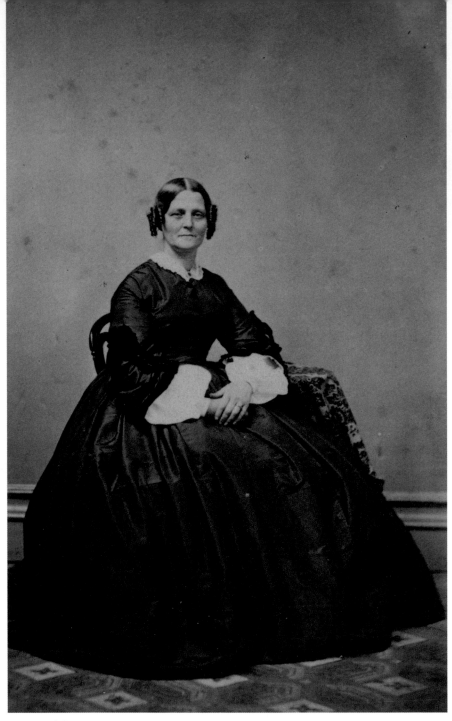

Sarah Davis

This particular letter also represents many others in the Manuscripts Department that discuss some person or group's reaction to the assassination of Abraham Lincoln and, most often although not always, mourn the national tragedy.

———◆———

The Davis family collection consists of roughly twenty-four linear feet of material and represents the types of family collections that the Manuscripts Department holds. The correspondence between Davis and his wife in the 1840s and 1850s is often used for context on matters related to Abraham Lincoln and legal practices in Illinois during the period. However, the collection also contains information on the construction of the Davis home in Bloomington in the 1870s (now a state historic site), Davis's business interests, his management of Lincoln's estate, and postwar concerns while Davis served on the Supreme Court and in the Senate. Davis's descendants placed the collection in the Library on loan in 1959. In 1979, the Library inherited the papers after the death of Davis's great-grandson.

This picture—the only surviving photograph of the dead president—was a hidden treasure for almost ninety years until a fourteen-year-old student found it while doing research in the Library's collections during a 1952 summer visit to Springfield.

Secretary of War Edwin M. Stanton forbade photography of Lincoln's body to prevent commercial exploitation. Nevertheless, New York photographer Jeremiah Gurney Jr. took two pictures from a gallery twenty feet above the open coffin while the president lay in state on April 24, 1865, in City Hall, New York City. The image included General E. D. Townsend and Admiral Charles H. Davis, who were standing guard. When Stanton learned of the pictures, he severely reprimanded the officer in charge and ordered the immediate destruction of the photographic plates. Although the plates were destroyed, one print was preserved and sent to Stanton. For whatever reason, Stanton failed to destroy it. Stanton's son Lewis found it in his father's papers and in 1887 sent the print to Lincoln's former secretary John Nicolay, who was co-writing a biography of Lincoln with John Hay, also a former Lincoln secretary. Nicolay did not tell anyone about the photo but placed it in a file among his papers. Hay's daughter donated the Nicolay-Hay papers to the Library in 1940. The picture remained hidden in the file until July 20, 1952.

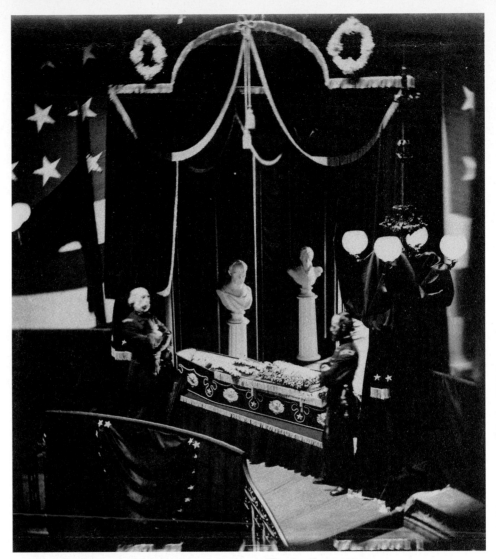

Death photograph of Abraham Lincoln in his coffin, April 24, 1865
(4½″ high × 4″ wide)

Morris, Minn
Jan. 17th /87

John G. Nicolay

Washington D.C.

Dear Sir

In going over my father's papers I came across this enclosed photograph. Possibly it may be of use to you and Col Hay, tho' I do not think it probable. Give my regards to Miss Nicolay whom I regret not seeing while in Washington. What do you think of 'McClellan's Story'?

Yours sincerely
Lewis H. Stanton

Letter from Lewis T. Stanton to John G. Nicolay, January 17, 1887, that accompanied the Lincoln coffin photo

Lincoln Coffin Photograph

In November 1951, at the age of fourteen, I attended a two-day dedication of the Judge James W. Bollinger Collection at the University of Iowa. I was a guest because I had been a corresponding friend of Iowa's oldest Lincoln collector, Judge Bollinger. Approximately sixty collectors and students were present at the evening dedication. Dr. Harry E. Pratt, Illinois state historian, took a liking to me and invited me to come to Springfield and stay with him and his wife, Marion, as their guest.

After breakfast on Sunday morning, July 20, 1952, Dr. Pratt and I went to the Centennial Building. He was writing a review of a book and took me to the Lincoln-Horner Room and said he would open up the file of the Nicolay-Hay Collection. I should feel free to take anything out, walk into the Lincoln-Horner Room, sit down, and look at it.

I found a file folder marked X: 14. I opened the file and began reading Nicolay's notes. Then I saw an envelope laying there dated 1887, sent from Minnesota to John Nicolay at Washington, D.C. I opened it and found two pieces of regular stationary folded in thirds, along with a small note; I laid the pieces aside. I began reading the letter from Lewis H. Stanton, son of Lincoln's secretary of war Edwin Stanton.

I folded the letter and put it back in the envelope, returned it to the manila folder, and then discovered I had left out the contents. As I opened up the folded sheet of plain stationary, there lay in the middle fold a small faded brown photograph. I thought it was sepia tone at first, and then I immediately knew what it was! I picked it up and ran down to Dr. Pratt's office, declaring, "Harry, look at what I just found! This is a picture of Lincoln in his coffin taken in New York City at the time of the funeral!"

Dr. Pratt looked at the photograph and said, "Oh! Let's check you out to see if you are right." So we returned to the Lincoln-Horner Room. Dr. Pratt asked me to "keep still" about the discovery.

On September 14, 1952, Associated Press released the photograph, along with my name, from New York, and the news of the discovery of the last photograph of Lincoln was now told in various papers

across the nation. Awakening me early that morning, my mother asked, "What did you do wrong? Your Grandpa Rietveld called and said your name is on the front page of the *Des Moines Register*."

Discovering the Lincoln coffin photograph greatly encouraged my interest in pursuing a career in history. While in the fifth grade, I consumed Carl Sandburg's six volumes of the life of Lincoln, corresponding with Sandburg as well. I wrote to Lincoln sites for brochures and information and began corresponding with others who were also interested in Lincoln, especially those who had befriended me at the Bollinger Collection dedication. I also corresponded with the last living Civil War veterans. I later completed both my A.M. and Ph.D. at the University of Illinois at Urbana-Champaign and served as research assistant to Dr. Robert W. Johannsen, then working on his biography of Stephen A. Douglas.

Throughout all these years, as Professor of History, I have continued to research, write, and speak on the life and times of Abraham Lincoln. My academic career has been spent in the classroom at Wheaton College (Illinois) and at California State University, Fullerton.

Ronald D. Rietveld,
Emeritus Professor of History
California State University, Fullerton

Just as Abraham Lincoln had done during the Civil War, Andrew Johnson, his successor, issued several amnesty proclamations after the war ended. The first of these, issued May 29, 1865, offered amnesty and pardon to Confederates, with certain exceptions, who took a loyalty oath. Fourteen classes of Southerners were excluded and had to apply individually to President Johnson. The exceptions included officials of the Confederate government, military officers ranking higher than colonel, persons under indictment for any offense, persons who had resigned from the U.S. Army to fight for the Confederacy, West Point graduates who became Confederate officers, and persons who had more than $20,000 worth of property. Three of these categories applied to Robert E. Lee, the most prestigious Confederate general, and he was concerned that he might also be indicted for treason. For this reason, Lee wrote to Ulysses S. Grant for clarification and support, which Grant provided in a letter to Secretary of War Edwin M. Stanton.

This collection, purchased by the Library in 1938, also contains Lee's letter to President Johnson applying for pardon and amnesty, as well as a letter from Grant recommending

Robert E. Lee to Ulysses S. Grant, June 13, 1865 (9¾″ high × 7¾″ wide)

Ulysses S. Grant to Edwin M. Stanton, on reverse of Lee letter

that Lee be pardoned (neither shown here). Johnson did not pardon Lee individually, but he was included in a universal pardon issued by Johnson on December 25, 1868. In 1970 an archivist discovered Lee's amnesty oath, signed October 2, 1865, in the National Archives. President Gerald Ford officially "pardoned" Lee in ceremonies on August 5, 1975.

Richmond 13 June '65

Genl

Upon reading the Presidents proclamation of the 29 Ulto: I Came to Richmond to ascertain what was proper or required of me to do; when I learned that with others, I was to be indicted for treason by the Grand Jury at Norfolk. I had supposed that the officers & men of the Army of N. Virga were by the terms of their Surrender protected by the U.S. Govt; from molestation, so long as they Conformed to its conditions.

 I am ready to meet any charges that may be preferred against me, & do not wish to avoid trial, but if I am Correct as to the protection granted by my parole, & am not to be prosecuted; I desire to Comply with the provisions of the Presidents proclamation & therefore enclose the required application, which I request, in that event, may be acted on

<div align="right">

I am with great respect
Your obt servt
R E Lee

</div>

Lt Genl U. S. Grant
Commd the Armies of the U. States

[File note on reverse of letter]

L 29. AuS 1865

Richmond, 13th June '65

Lee, R. E.

 Understanding that, with others, he is to be indicted for treason by the Grand Jury at Norfolk, states his readiness to meet any charges that may be brought forward. Had supposed that the terms of his surrender protected him. If they should, he desires to comply with provisions of amnesty proclamation and therefore encloses the required application which in that event he requests may be acted on

one enclosure

Recd A.uS. June 16, 1865

 Respectfully forwarded to the Secy of War.

 In my opinion the officers and men paroled at Appomattox C.H. and since upon the same terms given to Lee, can not be tried for treason so long as they observe the terms of their parole. This is my understanding. Good faith as well as true policy dictates that we should observe the conditions of that convention. Bad faith on the part of the Governm't or a construction of that convention subjecting officers to trial for treason, would produce a feeling of insecurity in the minds of all paroled officers and men If so disposed they might even regard such an infraction of terms by the Government as an entire release from all obligation on their part.

 I will state further that the terms granted by me met with the hearty approval of the President at the time, and of the country generally. The action of Judge Underwood in Norfolk has already had an injurious effect, and I would ask that he be ordered to quash all indictments found against paroled prisoners of war, and to desist from further prosecution of them

<div align="right">

U. S. Grant
Hdqrs AuS. June 16, 65 Lieut. General

</div>

Andrew Johnson,

President of the United States of America,

To all to whom these Presents shall come, Greeting:

Whereas, on the twenty ninth day of June in the year 1865, Dr. Samuel A. Mudd was by the judgment of a Military Commission, convened and holden at the City of Washington, in part convicted, and in part acquitted, of the specification wherein he was inculpated in the charge for the trial of which said Military Commission was so convened and held, and which specification in its principal allegation against him, was and is in the words and figures following, to wit: "And in further prosecution of said conspiracy, the said Samuel A. Mudd did, at Washington City, and within the Military Department and military lines aforesaid, on or before the sixth day of March, A. D. 1865, and on divers other days and times between that

Samuel A. Mudd, a rural Maryland physician and tobacco farmer, treated John Wilkes Booth's broken leg as Abraham Lincoln's assassin fled Washington, D.C. Accused of complicity in the president's assassination, Mudd was found guilty in June 1865 and sentenced to life imprisonment at Fort Jefferson, Florida, in the Dry Tortugas islands near Key West. After Mudd cared for his fellow prisoners and the military garrison during a yellow fever outbreak in 1867, sentiment favoring Mudd's pardon increased. Andrew Johnson decided to grant pardons to Mudd and the other surviving assassination conspirators just before he left the presidency.

This official document, written by a clerk, was signed both by President Andrew Johnson and by Secretary of State William H. Seward. It bears an official seal. In 1954 the Library received this important document and three letters written by Mudd as a gift.

President Andrew Johnson's pardon of Samuel A. Mudd, first and last pages, February 8, 1869 (15½″ high × 10¾″ wide) (six pages text, total)

unto moving, do hereby grant to the said Dr. Samuel A. Mudd a full and unconditional pardon.

In testimony whereof, I have hereunto signed my name and caused the Seal of the United States to be affixed

Done at the City of Washington, this Eighth day of February, A. D. 1869, and of the Independence of the United States the Ninety third.

Andrew Johnson

By the President:

William H. Seward,
Secretary of State.

22

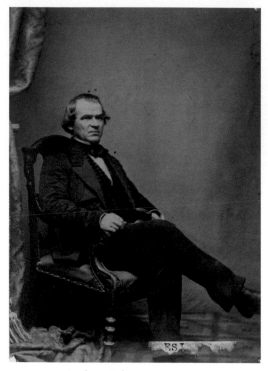

Andrew Johnson

Andrew Johnson,
President of the United States of America,

To all to whom these Presents shall come, Greeting:

Whereas, on the twenty ninth day of June in the year 1865, Dr. Samuel A. Mudd was by the judgment of a Military Commission, convened and holden at the City of Washington, in part convicted, and in part acquitted, of the specification, wherein he was inculpated in the charge for the trial of which said Military Commission was so convened and held, and which specification in its principal allegation against him, was and is in the words and figures following, to wit: "And in further prosecution of said conspiracy, the said Samuel A. Mudd did, at Washington City, and within the Military Department and military lines aforesaid, on or before the sixth day of March, A.D. 1865, and on divers other days and times between that day and the twentieth day of April, A.D. 1865, advise, encourage, receive, entertain, harbor and conceal, aid and assist, the said John Wilkes Booth, David E. Herold, Lewis Payne, John H. Surratt, Michael O'Laughlin, George A. Atzerodt, Mary E. Surratt and Samuel Arnold, and their confederates, with knowledge of the murderous and traitorous conspiracy aforesaid, and with intent to aid, abet, and assist them in the execution thereof, and in escaping from justice after the murder of the said Abraham Lincoln, in pursuance of said conspiracy, in manner aforesaid.;"

And whereas, upon a consideration and examination of the record of said trial and conviction and of the evidence given at said trial, I am satisfied that the guilt found by the said judgment against the said Samuel A. Mudd was of the receiving, entertaining, harboring, and concealing John Wilkes Booth and David E. Herold, with the intent to aid, abet and assist them in escaping from justice after the assassination of the late President of the United States, and not of any other or greater participation or complicity in said abominable crime;

And whereas, it is represented to me by intelligent and respectable members of the medical profession, that the circumstances of the surgical aid to the escaping assassin and of the imputed concealment of his flight are deserving of a lenient construction as within the obligations of professional duty, and thus inadequate evidence of a guilty sympathy with the crime or the criminal;

And whereas, in other respects the evidence, imputing such guilty sympathy or purpose of aid in defeat of justice, leaves room for

uncertainty as to the true measure and nature of the complicity of the said Samuel A. Mudd, in the attempted escape of said assassins;

And whereas, the sentence imposed by said Military Commission upon the said Samuel A Mudd was that he be imprisoned at hard labor for life, and the confinement under such sentence was directed to be had in the military prison at Dry Tortugas, Florida, and the said prisoner has been hitherto, and now is, suffering the infliction of such sentence;

And whereas, upon occasion of the prevalence of the yellow fever at that military station, and the death by that pestilence of the medical officer of the Post, the said Samuel A. Mudd devoted himself to the care and the cure of the sick, and interposed his courage and his skill to protect the garrison, otherwise without adequate medical aid, from peril and alarm, and thus, as the officers and men unite in testifying, saved many valuable lives and earned the admiration and the gratitude of all who observed or experienced his generous and faithful service to humanity;

And whereas, the surviving families and friends of the Surgeon and other officers who were the victims of the pestilence earnestly present their dying testimony to the conspicuous merit of Dr. Mudd's conduct, and their own sense of obligation to him and Lieut., Zabriskie and two hundred and ninety nine non commissioned officers and privates stationed at the Dry Tortugas have united in presenting to my attention the praiseworthy action of the prisoner and in petitioning for his pardon;

And whereas, the Medical Society of Harford County, Maryland, of which he was an Associate, have petitioned for his pardon, and thirty nine members of the Senate and House of Representatives of the Congress of the United States have also requested his pardon:

Now, therefore, be it known, that I, Andrew Johnson, President of the United States of America, in consideration of the premises, divers other good and sufficient reasons me there unto moving, do hereby grant to the said Dr. Samuel A. Mudd a full and unconditional pardon.

In testimony whereof, I have hereunto signed my name and caused the Seal of the United States to be affixed.

Done at the City of Washington, this Eighth day of February, A.D. 1869, and of the Independence of the United States the Ninety third

Andrew Johnson

By the President:

William H. Seward,
Secretary of State

STATE OF ILLINOIS, } ss.
 County of Cook.

We, the Undersigned, Jurors in the case of *Mary Lincoln*
.. alleged to be insane, having heard the evidence in the case,
are satisfied that the said *Mary Lincoln*
is insane, and is a fit person to be sent to a State Hospital for the Insane; that *S*he is a resident of the
State of Illinois, and County of Cook; that h*er* age is *fifty six* years; that the disease
is of *unknown* duration; that the cause is ~~supposed to be~~
unknown
..
.. ~~unknown~~ ;
that the disease is not with h*er* hereditary; that *S*he is not subject to epilepsy; that *S*he does not manifest
homicidal or suicidal tendencies, and that *S*he is *not* a pauper.

L. J. Gage S. C. Blake M. D.

J. McAdams C. B. Farwell

S. B. Parkhurst C. M. Henderson

Jas. A. Mason

D. R. Cameron

Wm Stewart

C. M. Moore

H. C. Durand

Thomas Cogswell

} **Jurors.**

Chicago, *May* 19 1875

Verdict of the jury in the Mary Lincoln insanity trial, May 19, 1875 (10½″ high × 8½″ wide)

Among the most misunderstood episodes in the life of the Lincoln family is Mary Lincoln's period of alleged insanity in 1875.

During the Civil War, Mary Lincoln lost several brothers who fought for the Confederacy, plus her favorite son, Willie (age eleven), in 1862, followed by the assassination of her husband in April 1865. After the war her youngest son, Tad (age eighteen), died in 1871. Mary did not recover well from the deaths of her sons or her husband. Yet a July 1863 carriage accident in which Mary was seriously injured when she hit her head on a rock, caused an unfortunate personality change more than did the deaths of her loved ones, according to her surviving son, Robert.

Each spring at Easter time (Lincoln was shot on Good Friday) Mary became depressed. Beginning in March 1875, approaching the tenth anniversary of Lincoln's death, her behavior became increasingly bizarre. She had hallucinations about Robert's health and about fires in Chicago, heard voices, believed people were trying to poison her, spent money wildly (including buying forty pairs of curtains), was agitated, and could not be left alone. After two months of these and other symptoms, Robert, Mary's other relatives and long-term acquaintances, and a team of doctors believed that intervention was necessary. Opportunities to intervene were limited at the time. To confine her to an institution required a sanity trial. At that trial, held in Chicago on May 19, 1875, the jury took eight minutes to declare her insane, based on the evidence presented.

Mary spent May 20 to September 11, 1875, in the Bellevue Place Sanitarium, a private institution for women in Batavia, Illinois. The gentle treatment she received there evidently worked, although Mary complained a great deal before being released in September to the custody of her sister Elizabeth Edwards in Springfield.

Historians differ as to whether Mary was truly insane. While she had mental and emotional issues on other occasions, clearly her problems in 1875 were much more extreme than at any other time. Several researchers have suggested that she may have had problems with medication, which resulted in the hallucinations and other difficult behavior.

The truth will probably never be known. However, the jury of merchants, doctors, and other men of that class judged her insane by reason of unknown causes. This jury verdict page is one of the Library's most recent and important Lincoln family acquisitions, a transfer from the Illinois State Archives and Circuit Court of Cook County in November 2011.

KEE-O-KUCK OR THE WATCHING FOX

The present Chief of the Sauk tribe and Successor to Black Hawk.

Painted by J.O. Lewis at the great treaty of Prairie du Chien 1825.

Keokuk from *The Aboriginal Port-folio* by James Otto Lewis, 1835 (17½″ high × 12″ wide)

7. *Ethnicity*

Hired by the U.S. Bureau of Indian Affairs in the 1820s, James Otto Lewis (1799–1858) attended government-sponsored Indian councils and treaty ceremonies during which he prepared paintings of notable Indians. These were distributed in *The Aboriginal Port-folio*, issued in 1835 in ten installments of eight hand-colored lithographs each. Due to some publishing problems, most extant copies, including the Library's, only have nine installments, with a total of seventy-two plates. The Library purchased its copy in 1934.

Keokuk (ca. 1790–1848), a Sauk Indian chief in Illinois and Iowa, usually counseled his tribe to submit to the demands of the U.S. government.

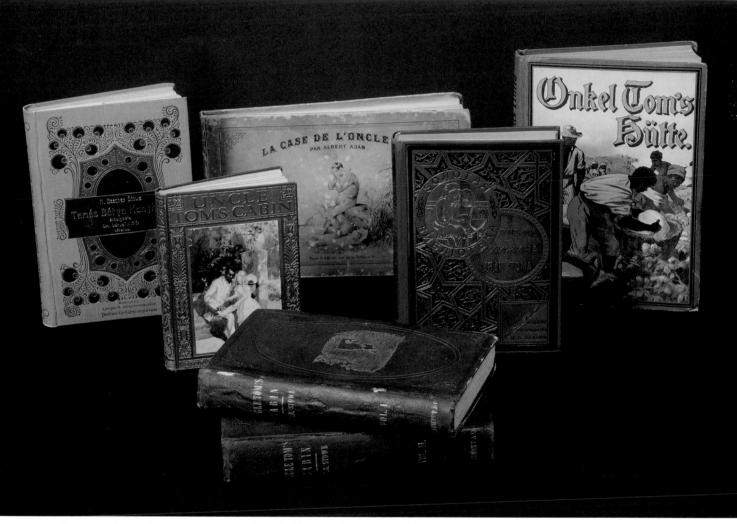

Examples from the Sang collection of *Uncle Tom's Cabin* editions: (*foreground*) original 1852 two-volume version, either first or second printing; (*background, left to right*) undated versions in Hungarian, English (for children), French (mostly illustrations), Russian, and German

Uncle Tom's Cabin, the most famous American novel, was written by Harriet Beecher Stowe (1811–1896), minister's wife, mother of seven, and author of numerous more obscure works. A protest against the Fugitive Slave Law passed by Congress as part of the Compromise of 1850, Stowe's novel was first published as a weekly serial in *The National Era*, a newspaper, in 1851–1852 before being issued as a two-volume book in March 1852. A runaway bestseller in the North, but thoroughly execrated in most of the South, *Uncle Tom's Cabin* appeared in many editions in America, and in numerous international translations. The book is widely considered to have furthered the polarization of the North and the South that led to the Civil War. Abraham Lincoln allegedly called it the cause of the war. The novel's popularity continued long after the Civil War, however, especially because of traveling dramatic troupes that gave performances of the story across the nation. *Uncle Tom's Cabin* remains in print in the twenty-first century.

Philip D. Sang (1902–1975) of River Forest, Illinois, was a major collector of historically valuable books and other items. His long-term connection with the Illinois State Historical Society led him and his wife Elsie to donate this important collection of *Uncle Tom's Cabin* volumes and books related to Stowe to the Illinois State Historical Library in the mid-1950s. Consisting of about 250 volumes, the collection includes a copy of the two-volume first or second printing (they are identical), editions of the novel in twelve languages, and two printings of a comic book version of the story, differentiated by their cover art. The Library is an unexpected location for this nationally significant treasure that is of value to scholars of Stowe and the effects of her crucial publication.

| Phillip S. Post, Dept. Commander, Galesburg, Ill. | H. P. Thompson, A. A. G. Cor. Wabash Avenue and Hubbard Court, Chicago. | John G. Mack, C. M. O., Springfield, Ill. |

NOTE—Ten or more names are necessary to organize.

GRAND ARMY OF THE REPUBLIC.

The undersigned honorably discharged Ex-Soldiers and Sailors who served in the Union Army during the late Rebellion, between the 12th day of April, 1861, and the 9th day of April, 1865, respectfully petition you to organize a Post of the Grand Army of the Republic, at _Springfield_ County of _Sangamon_ Illinois.

(Return to the Chief Mustering Officer, with $15 for Charter and Supplies.)

NAME.	RANK.	COMPANY.	REGIMENT.
Edward Mallay	Private	A	3. U.S. C.I.
Isaac Gastin	" "	C	29. U.S. C.I.
Arthur Young	Private	C	6. U.S. C. Cav
Lewis Kirby	"	B	115 U.S. C Infty.
Cicero Dickson	Private	A	30. U.S. C.I.
Harrison Richardson			55. Mass C.I.
Joseph Hazelwood	Corpl	K	17. U.S. C.I.
Franklin Davis	Color Bearer	C	29. U.S. C.I.
William Freeman	Private	A	3. U.S. H. C Arty
Thomas Shephard			1st Mo Battery
James Maxwell	Private	A	45. U.S. C.I.
Henry Van Treico		A	29. U.S. C.I.
Thomas Jones	Private	G	29. U.S. C.I.
Wyatt Johnson	"	K	27. U.S. C.I.
Moses Bohanan	"	G	60. U.S. C.I.
Isaac Parks	Private	D	59. U.S. C.I.
William Virden	" "	A	29. U.S. C.I.
Lewis Austin	" "	E	29. U.S. C.I.
Watt Veal	Sergt	H	29. U.S. C.I.

Application for charter for the John A. Bross GAR Post 578, Springfield, Illinois, 1886 (14″ high × 8½″ wide)

The Grand Army of the Republic (GAR), a national organization of Civil War veterans, was founded in Springfield or Decatur, Illinois, in 1866 and ceased to exist with the death of its last member in 1956. The Library holds records for most of the eight hundred Illinois posts, usually quarterly reports. Genealogists find these records of particular interest because for each new member, the report listed his state of birth; age; occupation; date of enlistment; rank; company, regiment, or ship where served; date and cause of discharge; and length of service. For some members, a date and cause of death are given. Books of meeting minutes are also available for a minority of the posts.

In the twenty-first century researchers have discovered posts of exclusively black veterans in Chicago, Springfield, Cairo, and Murphysboro. More recently, some integrated posts have also been found, in Illinois and elsewhere.

In May 1886 nineteen black veterans organized what became Post 578 in Springfield. They named it for John A. Bross, colonel of the 29th U.S. Colored Infantry, which included many Illinois soldiers. Bross was killed in the assault on Petersburg, Virginia, in the aftermath of the explosion of a mine under the Confederate fortifications on July 30, 1864. The post was chartered on May 22, and the charter was sent August 9, 1886.

African American History and the GAR

It doesn't take a trained historian to bring new chapters of African American history to light; it simply takes effort and desire. The most recent renovation of my business card is emblazoned with the words, "Passionate for all things African American." And, I'll proudly confess to anyone that I am a "half-breed"—part genealogist, part historian!

For anyone out there looking to really "discover" African American history, grabbing books off the shelf in the main reading room of your favorite library may get you somewhat oriented—but will in NO WAY bring you to your objective.

My introduction to the Grand Army of the Republic (GAR), an organization of Civil War veterans, came in the form of a book that transcribed the death notices of Illinois members received by headquarters, spanning a period of sixty-nine years. I was mesmerized by the sea of names and military units and spent months extracting the African American veterans into a database. Information gleaned from a few government resources and substantial newspaper research supplemented my knowledge base.

Ultimately, however, it was the use of a collection of post records in the Manuscripts Department at the Abraham Lincoln Presidential Library that allowed the transformation of a group of disordered fragments into a historical paper presented at the Eighth Annual Conference on Illinois History in October of 2006, titled "African Americans and the Grand Army of the Republic in Illinois."

The rich history of the African American experience does not have to lie dormant within the larger historical record. The documents await you. At the Library, I found a staff that was not particularly impressed by the number of degrees a patron held, but by his level of enthusiasm!

Timothy N. Pinnick
Independent scholar, North Aurora, Illinois

John A. Bross

S. Benensohn, YORKVILLE, ILL.

Nathan Hughes with his second wife, Jane, Yorkville, Illinois, ca. 1883
(7″ high × 5″ wide)

Similar to cartes-de-visite in manufacture but larger in size, cabinet card photographs were popular from the 1870s through the 1890s. A particularly exciting treasure, a gift to the Library from two Chicago families in March 2012, is a cabinet card photograph of Nathan Hughes (ca. 1830s–1910), who had served in Company B, 29th United States Colored Troops (USCT). This was the only African American regiment raised in Illinois, a process begun in the fall of 1863. Hughes, an escaped slave from Kentucky, joined the regiment in Chicago in January 1864. After being severely wounded in the left leg at the Battle of the Crater at Petersburg, Virginia, in July 1864, Hughes was hospitalized for a time but eventually rejoined his regiment and served until mustered out in December 1865. After the war, he farmed in Kendall County, Illinois, where he joined, and was one of the officers of, the evidently integrated Post 522 of the Grand Army of the Republic (GAR) in Yorkville. (He is wearing his GAR badge in the photo.)

Images of USCT soldiers who can be identified, whether in uniform or not, are rare. This is the only one from the 29th USCT held by the Library.

David Frances Barry (1854–1934) was a photographer located in West Superior, Wisconsin, about 1890. He took many photographs of Native Americans, including his friend Rain-in-the-Face (ca. 1835–1905) and Sitting Bull (ca. 1831–1890), both noted Hunkpapa Sioux chiefs. Barry autographed both of these photos, which the Library acquired in 1958.

◆

While many people in this country think of African Americans, Hispanic Americans, and Native Americans when they hear the term "ethnicity," the word can also apply to immigrants from various European and other nations.

Sitting Bull by David F. Barry (13¾″ high × 10¾″ wide)

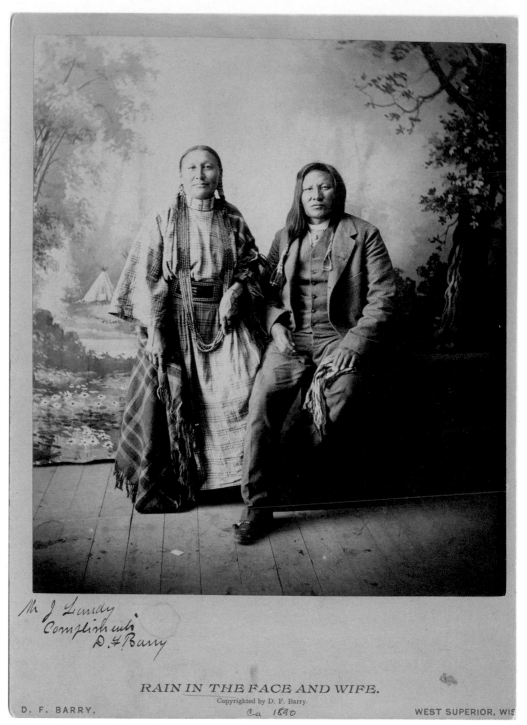

Rain-in-the-Face and his wife by David F. Barry (11¼″ high × 8″ wide)

A Scrapbook as Synthesis

Church archives, like those of many local institutions, often challenge someone wanting to write a history of the congregation. The records, often incomplete and in disarray, usually tell the researcher too much about some aspects or periods and very little about others. When asked to do a centennial history for my own church, the Lutheran Church of St. Luke in Itasca, Illinois, I wanted to go back to the very beginning, to the very first pastor and the earliest German immigrants in northern DuPage County. The name of Franz (Francis Arnold) Hoffmann, appearing in several secondary sources, soon caught my attention. A check in the standard biographical sources for American history quickened my pulse. Could the genesis of the Lutheran church in our area be connected with the Lieutenant Governor of Illinois during the Civil War?

Hoffmann, after leaving the area, became a Chicago alderman, leader of the German community in the city and state, journalist, supporter of Lincoln, businessman, agricultural authority, and author of important books addressed to the German-speaking people in the Midwest. Confirming that some of his papers were in the Abraham Lincoln Presidential Library, I could not wait to get to Springfield. The key item for my purposes was a scrapbook probably compiled by Minna Frances Hoffmann Nehrling, a granddaughter, along with her typescript memoirs recalling her experiences with her grandparents. The scrapbook brought together various aspects of Hoffmann's life, even if it had few references to his early career as a teacher and Lutheran pastor. What it did do, and do so well, was to bring together the various dimensions of this immigrant's career in the nineteenth century, enshrining, in a modest way, the multiple contributions he made to American life in general and the Illinois experience in particular.

Gerald A. Danzer
Professor of History Emeritus, University of Illinois, Chicago

Directory of Sangamon County's Colored Citizens, 1926 (9″ high × 6″ wide, closed)

Wanting more than a simple alphabetical listing of names and addresses of the "colored citizens" of Springfield, the compilers of the 1926 *Directory of Sangamon County's Colored Citizens* set as their goals to identify "the colored citizens of Sangamon County who are worth knowing," to provide "an account of the relation of the colored people to the early history and development of the county," to spread knowledge about the political candidates who are seeking office so "that an intelligent exercise of the ballot" can be made, and to put "the substantial Colored Citizens in close touch with the dominant race."

As a result, this directory included numerous advertisements for services from "colored" businesses, entrepreneurs, churches, amusements, and organizations. There were ads for many political candidates, as well as full page biographies of some of the "leading citizens."

The directory also contained an article titled "History of the Colored People in Sangamon County" by W. T. Casey. This section indicated that the first African American settler came to Sangamon County eighty-seven years before, discussed the 1908 race riot in Springfield, and commented that the black citizen "has been practically barred from [political] office and has lacked the official experience which the responsibility of office brings to the white citizen."

Very few institutions have copies of this directory. The Library purchased the directory new in 1926 from W. T. Casey.

———————◆———————

The Colored Embalmer, published in Chicago from 1926 to 1937, was the official publication of the Independent National Funeral Directors Association and the first African American trade journal of any type. Robert R. Reed, the editor, was a journalist and embalming fluid salesman who proposed to discuss the mortuary profession from a "Negro" viewpoint. It was among the "race publications" of that era, a term used to identify efforts to "uplift the race."

The Library holds seven issues (1928–1929) of this unusual publication, which included illustrated articles about the profession and advertisements for funeral homes and products.

Interior Views of the Chas. Crook Funeral Home 4638-40 Indiana Ave., Chicago, Illinois

CASKET DISPLAY

PRIVATE OFFICE

EMBALMING ROOM

CHAPEL

RECEPTION ROOM

DRESSING AND LAY-OUT ROOM

Two-page spread of photos of the Chas. Crook Funeral Home in Chicago, *The Colored Embalmer*, volume 2, number 8, March 1929 (12″ high × 18½″ wide, open)

A Marvel

I love the Abraham Lincoln Presidential Museum. I visit it often and always marvel at its exhibits and displays.

But, as an Illinois historian, I know that across the street from the Museum is another of the true gems of our state: the Abraham Lincoln Presidential Library. The Library is home not just to an unsurpassed collection of Lincoln material but also to the Illinois State Historical Library. For historians, students, researchers, and genealogists wishing to study Illinois, the Midwest, or even that fellow Lincoln, the Library is the place to go.

In the late 1990s, I began doing research at the Illinois State Historical Library. It was then housed, seemingly as an afterthought, in the cramped and windowless basement of the remodeled Old State Capitol. One entered through an underground parking garage.

The bright new Library is a state-of-the-art facility. The main research room is expansive and well lit. The Library's manuscripts and photo collections each have their own area for research. With the new building, the Library is able to place some of its most extraordinary materials on display, such as in the very successful *Boys in Blue* photograph exhibits commemorating the sesquicentennial of the Civil War.

Most of my time, however, is spent in the newspaper collection area. The Library houses microfilm copies of more than five thousand Illinois newspapers, dating back to before statehood. This specialized collection, which has been so helpful to me, needs a large, user-friendly area. The Old State Capitol just didn't have the space for persons working with this collection. The new Library more than doubled the area for use of this collection.

Since it opened, I have been using the new Library facility. As with the Museum, I visit the Library often and find it to be a marvel.

David A. Joens
Director, Illinois State Archives, Springfield

Murvin White to folks at home, July 26, 1918
(9½″ high × 6″ wide) [p. 2 not shown]

My. address. Private Murvin White
Battery. A. 14th Bn. F.A.R.D.
[American flag on left] [Knights of Columbus
 emblem on right]
KNIGHTS OF COLUMBUS
War Activities Camp Taylor, Ky.
Camp Taylor, Ky

July 26—1918

Dear folks at home

I will write you a few lines to let you know I am still Here at Camp Taylor well it rained this evening and is still raining I suppose your are all Well. I am as well as common. Well I have changed around a right smart I am in the third Barracks Since I left the tents and I guess I am going to be left here where I am for a while at least. Well henry is still in the tents. or he was night before last Wednesday evening We are in the same Camp. I expect we are about 3 quarters of a mile or a mile apart I reckon I have been over to see him 2 times Since I come over here I am In the artillery I guess if they don't change me any more [p. 2] Well I saw an air ship last Saturday the 20th it came right over our tents and sailed Around a while and finaly lit on the parade grounds and I Went over and saw It I got right up close to It and touched It It was a big air ship to there was to lieutenants came In it I saw the men they came from dayton ohio and they Stayed Over night and till In the evening of sunday and Sailed around over the tents again and turned over in the air and side ways and most every Way and they left It was a sight for me to See Henry saw It to I got a letter from orley to or three days ago He is all right Have you got the corn layed By Yet I suppose you have got the hay put up. Well I Will close for this time So good Bye

My address. Battery. A.14 battalion
5 regt. FARD
Camp Taylor Ky [address crossed through]

8. *World Wars I and II*

World War I mixed the "old" and the "new" in ways that people may not think about a century later. Horses still provided much of the transportation, although there were certainly motorized trucks and other vehicles in use as well. Airplanes were one of the new aspects of warfare, as recounted by Murvin White, an awestruck soldier who saw his first plane while stationed, caring for horses, at Camp Taylor in Kentucky.

White (1895–1979) was from Jasper County, Illinois. He and two of his five brothers (Henry and Orley) enlisted in the U.S. Army in 1918 and trained at Camp Taylor, Kentucky. Murvin and Orley served in France, and all three returned home safely. Murvin then farmed and worked for a shoe company in Greenup, Illinois.

World War I Veterinary Corps recruiting poster (19″ high × 25″ wide)

World War II cautionary poster
(28″ high × 20″ wide)

The Library has about eight hundred World War I broadsides (posters) and nearly as many from World War II. Horses still played an important role in military transportation during World War I, hence this recruitment poster for the U.S. Army Veterinary Corps.

———◆———

This World War II poster reminds people not to discuss information that could possibly endanger U.S. troops if learned by the enemy. The gold star banner indicates that someone in the household died in active service, probably in the navy, as suggested by the collar.

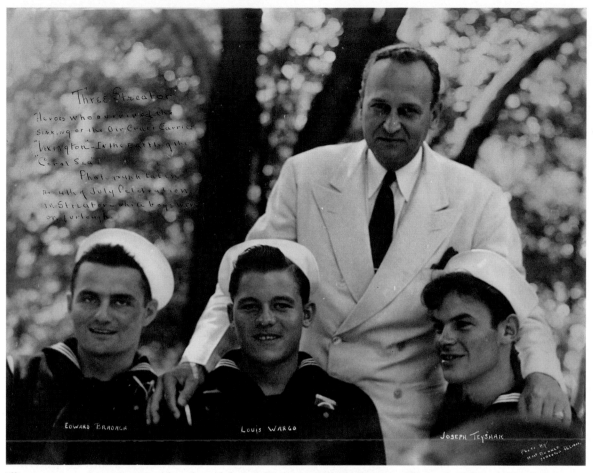

Illinois senator Scott Lucas with sailors (*left to right*) Edward Bradach, Louis Wargo, and Joseph Teyshak, Streator, Illinois, July 4, 1942, photo by H. McDonald (11″ high × 14″ wide)

The aircraft carrier *USS Lexington* was built in Quincy, Massachusetts, and commissioned December 14, 1927. While serving in the South Pacific during World War II, it was involved in the Battle of Coral Sea, east of New Guinea. On May 8, 1942, the ship was damaged by Japanese attacks, leading to a number of severe explosions on board. Edward Bradach, Louis Wargo, and Joseph Teyshak, all of Streator, Illinois, were among the 2,770 men rescued from the burning ship.

Scott Lucas (1892–1968), who served as an Illinois congressman (1935–1939) and U.S. senator (1939–1951), gave a large collection of manuscripts and photographs to the Library in 1964, with the rest arriving after his death in 1968.

Edwin W. Eek to Jack Robinson, March 12, 1943 (11″ high × 8½″ wide)

The Manuscripts Department has well over fifty collections containing World War II letters and documents. World War II letters were actively censored with potentially sensitive information cut out. (The Library has several samples of this practice.) Soldiers overseas could send letters free using the V-mail form. These forms were microfilmed with the reels sent back to the United States, where the letters were printed out in a small size and mailed to the recipient. This letter from Edwin Wilbur Eek (1916–2004) is an actual letter, not microfilmed. It represents all the Library's World War II collections. Eek was writing from the South Pacific.

The Bethel Chapel Bible School in Lyons, Illinois, devised a way to provide encouragement to soldiers absent from their class. They mailed the soldiers a list of Bible passages that the class would be studying. Each week the soldier was to write his comments on the passage, and a member of the class would respond with a letter. The leader of the class was John R. (Jack) Robinson (1890–1962), whose daughter gave the correspondence between Eek and her father to the Library in 2007.

[To] Mr. J. R. Robinson [From]
 173 Woodside Rd. Pvt. E.W. Eek 36033778
 Riverside Co. L 161 Inf.
 Illinois c/o Postmaster
 San Fran Cal.
 A.P.O. 25
 3–12–43

Hello Jack and Mrs Robinson,
Your Jan 23rd letter arrived with all of its welcome news. It was nice to hear of the whereabouts of every one.

 My last letter to you, dated 2/28 contains the balance of the lessons—altho in brief form

 We've finally had a breathing spell, and really appreciate it.

 The natives over here are friendly, and have a little understanding of the English language. They all are influenced by the missionarys who have built small chapels or churches about in the small 5 to 35 hut villages.

 They do farming under English influence, raising melons, potatoes, corn. Also cattle and hogs. All natives smoke and will barter most any possesions for tobacco.

 Pass on my best of wishes to all, and to you and yours,
 I remain
 as always
 Ed

 [ROBINSON'S NOTATIONS:]
 MAR 27 RECD
 APR 3 ANSD
 JRR letter

F896
C53
W956ca

Chicago's Candy Kettle, WPA Illinois Writers' Program and Art Project, 1941
(11″ high × 8¾″ wide; 42 pp.)

One of the "alphabet agencies" of the New Deal, the Works Progress Administration (WPA) was authorized on May 6, 1935, to provide work relief for the unemployed. Not just focused on construction projects, the WPA established programs using the skills of artists, musicians, theater people, and writers. The WPA ended once the demands of World War II made jobs readily available. Beginning in 1943 (after the end of the project) the Library acquired a large collection of papers from the Federal Writers' Project in Illinois—133 linear feet. In addition to manuscripts used for writing the Illinois state guidebook, the collection contains some photos and other project publications.

Late in the program the WPA name was changed to Work Projects Administration. Two ephemeral items from that period, published by mimeograph machine in 1941, have been chosen to represent the entire Writers' Project collection. *Chicago's Candy Kettle*, a short history of the city's candy makers, was aimed at schoolchildren, with illustrations by the Illinois Art Project.

Gone to Blazes, a similar-size publication about the Great Chicago Fire of 1871, assembles poems about the fire and its aftermath written by local authors. Evidently it too was directed at the school audience, but the use of verse was unusual.

Gone to Blazes, Episodes in Verse about the Great Chicago Fire, WPA Illinois Writers' Program and Art Project, 1941 (11″ high × 8¾″ wide; 45 pp.)

Music box owned by Mary Lincoln (10″ high × 24″ wide × 12″ deep)

9. Art

Mary Lincoln's music box was manufactured in Geneva, Switzerland, sometime after 1865. Still in working order, it plays ten different pieces from the mid-nineteenth century, mostly instrumental versions of popular opera excerpts, including works by Giacomo Meyerbeer, Charles Gounod, and Gaetano Donizetti. Mary probably purchased the music box, or received it as a gift, during one of her residences in Europe. After Mary's death, her sister Frances Wallace owned the music box. A Wallace family descendant gave this treasure to the Library in 1976.

Putting on the White Gloves!

When I first began to do research on the Lincolns, I remember deciding it would be important to come to visit the Library in winter, spring, summer, and autumn, but perhaps not exactly in that order, and not all in one year. But cycling through the seasons I would get to know the place Abraham and Mary called home—and walking home at dusk from the Library, past their home in the historic district to my little bed and breakfast, was an added attraction. So there I was, reading the largest collection of Mary Lincoln letters, coupled with diaries and correspondence from relatives and Springfield folk, so I could get to know the town in the nineteenth century. With each return visit, I also got to know the staff, the wonderful staff, who were so helpful and knowledgeable, and from whom I learned more and more with each dip into their incomparable collections.

I fondly remember a trip in spring, by which time I had some hopes of finishing my book, *Mrs. Lincoln: A Life*, in time for publication during the 2009 Abraham Lincoln Bicentennial celebration. So I was feeling a bit lighthearted and requested permission to look at some things from "the vault," full of artifacts that Lincolnistas coveted, that I had not yet viewed.

And lo and behold, I was told to put on the white gloves and be careful—as I was both in awe and giddy from the prospect. When I saw Mary's onyx ring with five diamonds (perhaps a tribute to the five men in her life—her husband and the four sons she bore)—it was too alluring, and I asked if I might try it on—and glove and all, I squeezed it onto my finger. Since I had gotten to know the archivists pretty well, I decided to play a trick, and so pretended (just for a moment!) that it had gotten stuck. And so there were a few flushed faces around the table, as one and all leaned in to help. And everyone broke into smiles when I promised I would to cut off my finger—if necessary—to return it; instead I slipped the gorgeous circlet off and back into the safety of its velvet-lined box. We all had a laugh, and I felt very privileged and pleased to share such camaraderie, among those proud conservators, working to keep the Lincolns and their legacy alive.

Catherine Clinton
Professor of History, Queen's University, Belfast, Northern Ireland

Mary Lincoln's diamond and onyx ring was passed down through the family of her sister Elizabeth Edwards and given to the Library in 1965.

---------◆---------

Little is known about Jerome D. Fielding (1822–1870) a Brockport, New York, artist who, having no formal training, painted in what has been called the "primitive" or "naive" style. He reportedly began his portrait of Mary Lincoln in the White House in early 1865 but after Lincoln's assassination was not able to finish his work there. Fielding noted on the back of the painting that he completed it in Brockport on December 18, 1865. In total, there are only about five known paintings of Mary Lincoln by any artist.

The painting was stored for a time in a basement, where it suffered serious damage when a water heater broke. Donated to the Library in 1994, the portrait has undergone careful restoration. Since 2010 it has hung in the Illinois Executive Mansion on long-term loan.

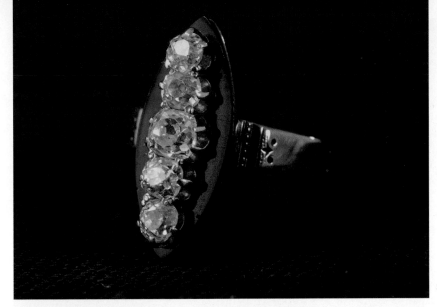

Mary Lincoln's diamond and onyx ring

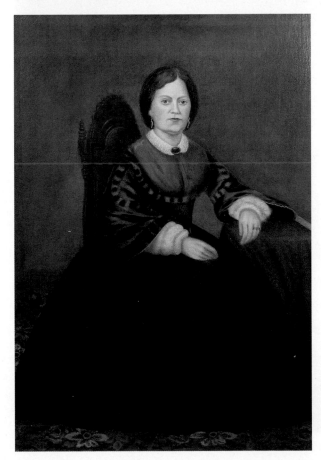

Portrait of Mary Lincoln by Jerome Fielding, 1865 (40″ high × 36″ wide)

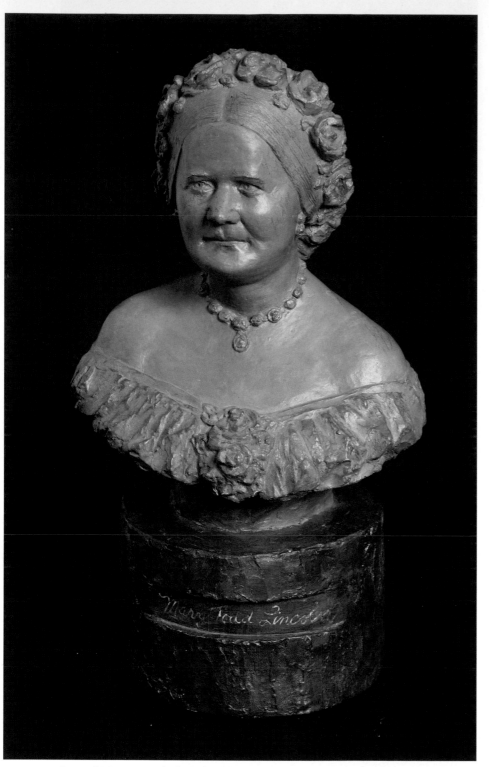

Bust of Mary Lincoln by Lily Tolpo, 1983 (14″ high)

Lily Tolpo (1917–2012), one of the best-known twentieth-century sculptors in Illinois, worked in a rural studio near Freeport with her husband Carl. This unusual depiction of Mary Lincoln, in plaster painted green, features several of her signature wardrobe accents: flowers in her hair, a necklace, and a ruffled, off-the-shoulder neckline.

The Library purchased the bust in 1984, the year after it was completed.

◆

Between 1933 and 1955, the Chicago and Illinois Midland Rail Road company hired three well-known Illinois artists to paint scenes from Lincoln's pre-presidential career to illustrate annual company calendars. The company gave twenty of these original paintings to the Library in June 2005.

This particular scene, by Fletcher C. Ransom, from the 1945 calendar, illustrates a "gander-pull," a common rural form of entertainment, primarily in the antebellum period, but not an activity that would be considered acceptable in twenty-first-century America. Here Lincoln is judging the contest in which riders raced past a greased goose or gander strung from a tree branch and tried to snap off its head. Lincoln's role was to be sure that the riders did not gain an advantage by slowing down as they approached the fowl. The winner got to take the dead goose home for dinner.

Lincoln the Arbiter by Fletcher C. Ransom, 1944 (29½″ high × 37″ wide, including frame)

A Research Epicenter

There is an epicenter to the study of Abraham Lincoln, in Springfield, Illinois, at the corner of Sixth and Jefferson. I mean, of course, the Abraham Lincoln Presidential Library and Museum, and especially its wonderful archives on all things pertaining to Lincoln. Perhaps it goes without saying that some great books have been hatched there. My opus, *Lincoln and Douglas: The Debates That Defined America*, certainly pecked through its shell in those marvelous confines in the summer of 2006. Under one roof, I was able to access microfilm of rare central Illinois newspapers from the campaign of 1858, riffle through correspondence between Lincoln's friends and enemies, even use census records to identify the wealth and status of members of the host committees in the seven debate locations.

But the biggest find of all came from a recommendation made to me by ALPL staffer Kathryn Harris. I knew that, in 1858, no one in Illinois voted directly for Lincoln or for Douglas; U.S. senators were still elected by state legislatures. The only way to gauge the effect of the debates on voters was to look at the returns of votes for the one hundred state House districts and the twelve open state senate districts in 1858. But where was I to find those? Accounts of the debates usually cited only the votes cast for two statewide races, for state treasurer and state superintendent of public instruction, and then assumed that those vote tallies somehow corresponded to the votes cast for legislative candidates. If the voters who elected James Miller and Newton Bateman (respectively) cast their ballots in the same way for Lincoln, then Lincoln won a popular, but very narrow, majority of 2,982 votes.

But I was not satisfied. I wanted to see what the actual vote count was, and so I went to Kathryn with my question. After a few fruitless searches, she suggested I look in the Illinois State Archives. I found the original vote ledgers there. The numbers they revealed were an entirely different story. Republican house candidates received 52 percent of the vote while Lincoln "won" the state Senate races by an even heftier landslide of 54 percent.

Except, of course, that he didn't. Unevenness in the apportion-
ment system gave Democratic districts more representation than
Republican ones, and even with fewer Democratic votes cast, more
Democratic representatives were elected to the legislature, and they
in turn elected Douglas. This meant that, without the lopsided
advantage of apportionment, Lincoln would have staged the po-
litical upset of the century. So, were the debates the great event we
suspected they were? Oh, yes, and here were the numbers to show it.
And all this came from one question, put to Kathryn in one place at
Sixth and Jefferson. It was the friendliest of research earthquakes, at
the friendliest epicenter.

Allen C. Guelzo
Professor, and Director, Civil War Era Studies Program
Gettysburg College, Pennsylvania

In the 1960s, at the time of the Civil War centennial and the centennial of Lincoln's presidency, the Ethan Allen furniture stores offered these folk art statues of the president. Although the piece appears to be hewn from wood, appropriate for a rail-splitter, the statue is actually cast steel, and hollow inside. The Library received this item as a gift in 2002.

Lincoln folk art standing statue from the Ethan Allen furniture company (42″ high × 9½″ wide × 6″ deep)

Although the bicycle was not invented until about five years after Lincoln's death, that did not prevent Illinois folk artist Ralph Arnett from imagining the president riding one as part of a series of historical figures on "High Wheelers." The Lincoln figure is made of wood resin and hand painted. He is separate from the hand-forged metal cycle, however, and neither piece can stand up independently.

This figure, made in 1988, is representative of many kinds of artwork—flat as well as three-dimensional—that imagine Lincoln in various anachronistic clothes, places, or situations. The Library purchased this bicycling Lincoln in 1989.

Folk art figure of Abraham Lincoln riding a big-wheeled bike
(28″ high × 9″ wide × 18″ deep)

Lincoln Weeps by Umberto Romano, 1959 (51″ high × 40¾″ wide)

This somber modernist painting, *Lincoln Weeps*, by Umberto Romano (1959) uses a "dribble technique," that was relatively new at the time, to express grief. His widow gave the artwork to the Library in 1998.

Romano (1906–1982), a native of Italy, came to the United States as a child but was influenced by the works of many master painters on trips back to Europe. He taught at the New York Academy of Design.

Eva Robert Ingersoll Brown by C. A. Wittemore, 1917
(20″ high × 17″ wide)

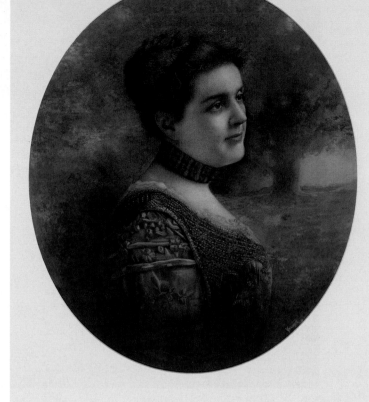

Maud Robert Ingersoll Probasco by C. A. Wittemore, 1916
(20″ high × 17″ wide)

These idyllic portraits of Eva Robert Ingersoll Brown (1863–1928) and her sister, Maud Robert Ingersoll Probasco (1864–1936), are favorites of the Audio Visual Department staff. Painted in 1916 and 1917 by C. A. Wittemore, the portraits are pastel and watercolor, based on earlier photographs, because the subjects were in their early fifties at the time the paintings were made.

Eva and Maud were the daughters of Illinois lawyer, lecturer, and outspoken agnostic Robert Green Ingersoll. Agnostics like their father, both women became social and political activists. Eva married Walston H. Brown in 1889, and in 1912 Maud married Wallace M. Probasco. The portraits came to the Library as part of a gift from the estate of Eva's daughter, Eva Ingersoll Brown Wakefield in 1971.

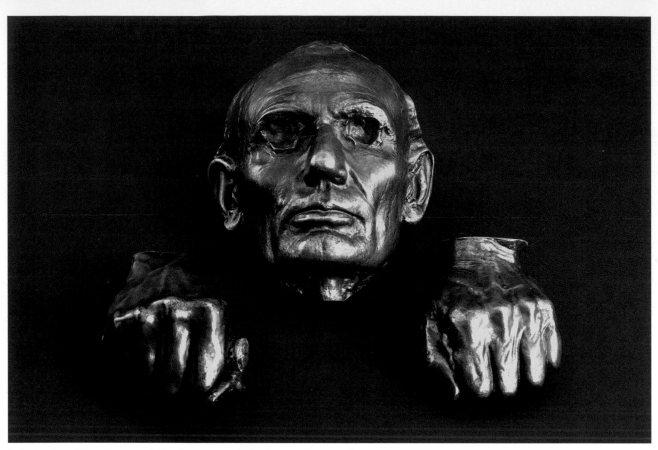

Life mask and hand casts of Abraham Lincoln by Leonard W. Volk, 1860

Life and death masks were fairly common ways of commemorating well-known white males in the nineteenth century. In some cases the masks were taken for use in determining proper proportions for sculpting a bust or statue. Abraham Lincoln had two life masks made, in 1860 and 1865, and there are casts of both in the Lincoln collection. Death masks were usually prepared within a few hours after the death of the subject. Life and death masks appear very similar and cannot be distinguished simply by looking at them.

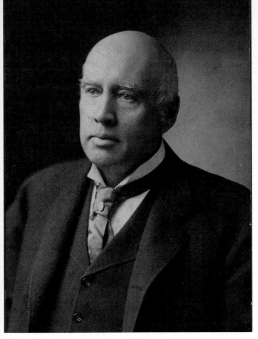

Robert G. Ingersoll in later life

Among its collections the Library's Artifacts Department has five life or death masks. Pictured is that of Robert Green Ingersoll (1833–1899), Illinois lawyer, Civil War cavalry colonel, and outspoken agnostic lecturer. This mask is unusual because it is actually a full head rather than just a face. Ingersoll's mask was given to the Library in 1947 by his granddaughter Eva Ingersoll Brown Wakefield.

Although the subject of one of the other masks is unknown, the rest are of Illinois governor Richard J. Oglesby (1824–1899), poet and artist Vachel Lindsay (1879–1931), and Hardin Wallace Masters (1845–1925), father of the poet Edgar Lee Masters.

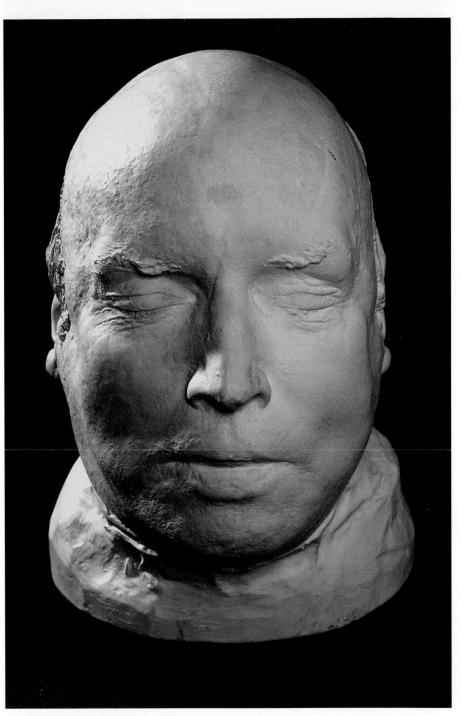

Robert G. Ingersoll death mask by George Grey Barnard
(11½″ high × 8″ wide × 10″ deep)

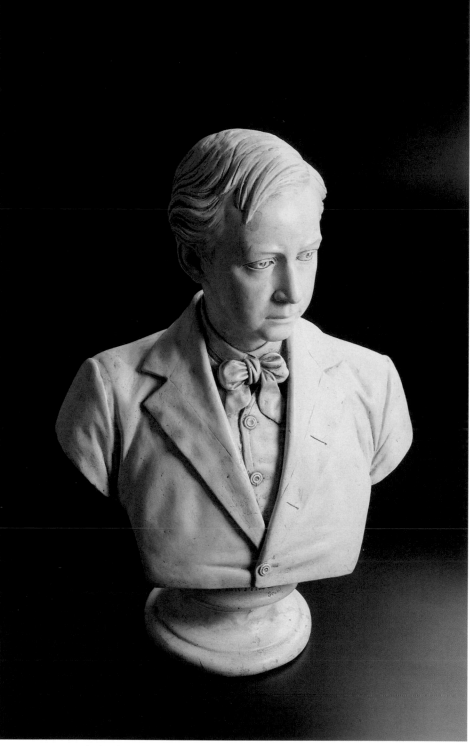

Abraham Lincoln II, called "Jack" by his family and friends, was the only son of Robert and Mary Lincoln and the only grandson of the president, for whom he was named. A bright boy, mature for his age, Jack was placed in boarding school in France in the fall of 1889 while his father was serving as the U.S. minister to Great Britain. In early November Jack received a cut on his arm that became seriously infected. After months of suffering, Jack died in England on March 5, 1890. He was only sixteen.

His sorrowing parents had a death mask made of Jack and commissioned Theophilus Fisk Mills to use it to make this porcelain bust, one of very few images of the young Lincoln. Mills was the son of Clark Mills, who made President Lincoln's second life mask in 1865. Robert Todd Lincoln Beckwith, the president's great-grandson and last living descendant, gave the bust of his uncle to the Library in 1978.

Bust of Abraham Lincoln II ("Jack") (25″ high)

Lincoln Treasures

I'll never forget my first time looking at the Lincoln Collection of what was then the State Historical Library in the basement of the Old State Capitol building, many years before the Presidential Library was built. I did not know what to expect, and the reading room was an ordinary room with tables and chairs and walls lined with books. When I went upstairs, however, to speak to the Lincoln collection curator, I immediately beheld a room filled with Lincoln items: in boxes, on boxes, lying on the floor, paintings leaning against other items. The first things I really saw were the two pieces of Eddie Lincoln's broken tombstone (about whose death I later wrote an article)—and that's when it became real that I was in the midst of history.

The first real treasure I used for my research was an item that then-curator Kim Bauer excitedly brought out and said no one had ever really looked at before. It was a scrapbook created by Robert Lincoln containing numerous newspaper clippings relating to his time as South Chicago town supervisor in 1876–1877 and his battle with the Democrats who had been illegally elected and removed from office but who were still trying to run the town government and, especially, collect town taxes. Robert Lincoln's fight with them went in multiple iterations to the county circuit court—where he won every time. To handle and examine that scrapbook, which Robert had created and where he had even written comments in the margins beside certain clippings, was an amazing experience. It was not only personal history, but an item that I knew had never been used by other scholars.

More than ten years later, while nearing the end of my research and writing for my biography of Robert Lincoln, current Lincoln curator James Cornelius took me into the Lincoln vault in the Presidential Library and showed me Robert Lincoln's original forty-plus volumes of letterpress books. I had been reading these books, containing copies of his personal correspondence from 1867 to 1912, for years on microfilm. To be in the actual Lincoln vault, to see the real volumes (as well as a photo album of Robert's trip to Yellowstone park as President Chester Arthur's war secretary and the original bust of Jack Lincoln commissioned by Robert and his wife, Mary), made my journey studying Robert Lincoln's life feel complete.

Jason Emerson
Independent historian and journalist, Cazenovia, New York

Helene Black (b. 1883), the lovely daughter of Danville, Illinois, lawyer and Civil War general John Charles Black and his wife, Adaline Griggs Black, had this photo taken by Stein in 1904 when she was twenty-one. Helene was well-educated for her era, both at the University Schools for Girls in Chicago and at Vassar College. Nevertheless, she was a staunch opponent of woman suffrage. She married Captain Stephen Abbot, a West Point graduate, on December 27, 1906. They eventually lived in Utah.

The Audio Visual Department has several hundred family photographs that were originally part of the John C. Black and Black-Abbot family collections in the Manuscripts Department. This photo was probably in a donation received by the Library in 1981.

Photo of Helene Black by Stein, 1904 (20″ high × 9¼″ wide)

Sister Institutions

The Abraham Lincoln Presidential Library is full of treasures! As the curator of Decorative Arts and History at the Illinois State Museum, I find the Abraham Lincoln Presidential Library a vital resource in my work. While the Illinois State Museum collects the material culture (historic artifacts) of Illinois, the Presidential Library's collection of historic documents, maps, and newspapers, and more—makes us complementary sister institutions preserving the history of Illinois. In partnership, we cross-reference our records when families donate artifacts to the ISM, and they have archived their family papers at the Presidential Library. Together, we work to tell the story of Illinois' past.

The Abraham Lincoln Presidential Library is an unmatched repository of Illinois' historic documents. A key component of my work is developing exhibitions. ALPL staff have been enthusiastically helpful in facilitating my research and crafting the visual aspects of exhibitions I have curated at the Illinois State Museum. Staff in the historic newspapers, manuscripts, historic photographs, reading room, and the Lincoln Collection have generously shared their knowledge, time, and granted permission to display digital reproductions. The Illinois State Museum has been able to display digital reproductions of maps, broadsides, photographs, and letters, which have greatly enhanced our visitor experience. Among my favorite documents were touching letters between husbands, wives, and children during the Civil War. These really gave an insightful perspective of life on the Civil War home front in Illinois. I look forward to my future work with the treasures at the Abraham Lincoln Presidential Library—which includes both their historic resources and their amazing staff.

Angela Goebel-Bain
Curator of Decorative Arts and History, Illinois State Museum,
* Springfield*

The fashionable Shirley Stratton (b. ca. 1923), second wife of Illinois governor William G. Stratton (1914–2001), posed for an unknown photographer in the Executive Mansion wearing her 1957 inaugural ball gown, described by the *Illinois State Journal* as being "pure silk satin, strapless, with a high waist effect." Stratton served two terms as governor (1953–1961) after having been a congressman and state treasurer for two terms each. More than 170 linear feet of Stratton's papers, including manuscripts, photographs, and other material, arrived at the Library in installments in 1970 and 1974, as well as in 2002 following Stratton's death.

Shirley Stratton in her 1957 inaugural ball gown (10″ high × 8″ wide)

Springfield, Illinois, socialite, art patron, and philanthropist Susan Lawrence Dana (1862–1946) prepared the art and the poetry of this gorgeous valentine in 1889 for her first husband, Edwin W. Dana (d. 1900). The illustrations for this work, which she titled "An Effect in Blue," are done in blue ink and blue wash. One of the most visually appealing items in the Manuscripts Department, this item was a gift from an Illinois manuscript collector about 1967.

Susan is best known in the art and architecture world for commissioning Frank Lloyd Wright in 1902 to design and construct what has come to be known as the Dana-Thomas house in Springfield, an important example of Wright's "Prairie" style.

Cover of Susan Lawrence Dana's valentine "An Effect in Blue," 1889 (10¼″ high × 8½″ wide, closed)

Two-page spread with first verse of poem and illustration from "An Effect in Blue" (10¼″ high × 17¼″ wide, open)

He sent me a valentine one day at
 school
Addressed to "My Little Pearl"
And great black words on the
 inside said
"For the darlingest little girl"
I was glad oh yes, yet the
 crimson blood
To my young cheek came and went
And my heart thumped wonder-
 ously pit-pat
But I dident know what it meant.

One night he said
I must jump on his sled,
For the snow was falling fast.
I was half afraid,
But he coaxed and coaxed
And got me on at last,
Laughing and chatting
In merry glee,
Down the hill
Like the wind we went,
My sisters looked
At each other and smiled
But I dident Know what it meant.

Ten years passed on they touched
 his eyes
With a shaddow of deeper blue,
They gave to his form a manlier
 grace
To his cheek a swarthier hue,
Down by the dreamy rippling
 brook
When the day was almost spent,
His whispers were sweet as words
 could be
And <u>now</u> I knew what it meant.

Scherenschnitte valentine (13″ in diameter)

This beautiful valentine is a prime example of serendipity in the Library: no one knows where or when something interesting will turn up. The Library's conservator discovered this valentine folded in *The Authentic Life of William McKinley* (1901) when she was repairing the book in 2005. The maker and recipient of the valentine are unknown.

Scherenschnitte (German for "scissor cuts") is a type of painstaking cut-paper folk art developed in Germany and Switzerland in the sixteenth century. In this case, the paper was folded during the process to produce eight identical designs. The maker wrote a circular message near the outside edge.

On the fourteenth day of February it was our lots for to be merry first we cast and then we drew and my choice fell on you as sure as the grapes grow on the vine this is my true drawing valentine so round is the ring that hath no end so is my love to you my friend the rose is red the vile blue Sugar sweet and so are you and now we will unite our hearts in twain for never more to part again if you take these lines in good respect I shall be glad with all my heart a present of you I expect but if you me disdain return my valentine again.

◆

Abraham Lincoln's two secretaries, John G. Nicolay and John Hay, not only wrote a massive ten-volume biography of the president, published in 1890, they also collected and edited many of his writings in a two-volume set entitled *The Complete Works of Abraham Lincoln* (1894) that was expanded to twelve volumes in 1905. Over the years there have been more than a dozen reprints of those sets, but one special and rare version was not discovered until 2009.

In that year, at the time of Lincoln's two-hundredth birthday, a dealer offered the Library an edition of twenty-four volumes copyrighted in 1905 in New York by F. D. Tandy. Although containing the same text as other twelve-volume printings, this special version included more than 350 full-page engravings. Bound in brown leather with gilded, stylized flowers on the front cover, the set is gorgeous. Inside the front cover of each volume is an oval with a painting of a log cabin, giving the edition its name. However, the greatest surprise of the edition is volume 24. Rather than printed text, this volume contains twenty-six original documents bound together to look like the rest of the volumes. The Library's copy contains an undated note from Lincoln to the secretary of war, as well as manuscripts signed by Secretary of State William H. Seward, Georgia Confederate politician Howell Cobb, Lincoln's arch-rival Stephen A. Douglas, future president Rutherford B. Hayes, Ohio politician and cabinet member Salmon P. Chase, and newspaperman Horace Greeley, among others. Each volume 24 assembles different documents.

The Library's set is number four of an offering probably sold by subscription, with a total projected run of eight sets for the edition. Although no library had previously cataloged the edition separately, publicity about the Library's copy has revealed at least nine other sets in public or private hands, not all of them labeled "Log Cabin Edition" but identical in other ways, including a volume 24 of original documents.

At nearly 125 years old, the Library continues to make new and exciting discoveries in the Lincoln and historical fields and to share those unexpected discoveries with anyone who is interested.

Exterior plus illustration inside front cover of "Log Cabin" edition of *The Complete Works of Abraham Lincoln* (9½″ high × 6½″ wide); oval 4⅓ high × 3¼″ wide)

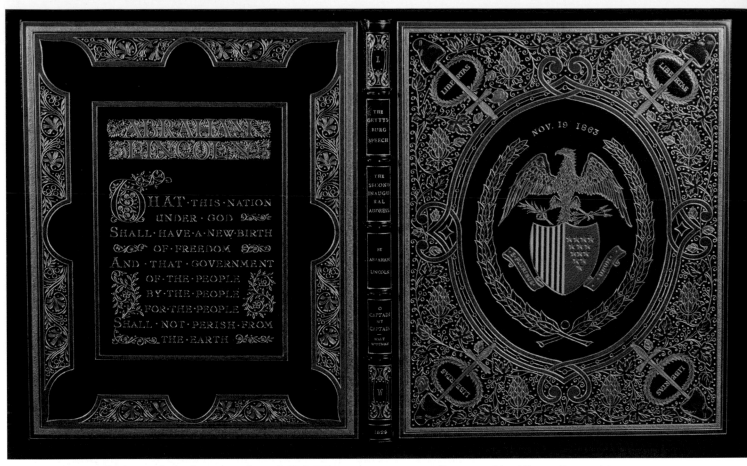

Cover of volume of Abraham Lincoln and Walt Whitman manuscripts illuminated by Alberto Sangorski (12½″ high × 10¼″ wide, closed, × 1″ deep)

Most people who have heard of illuminated manuscripts automatically think of a medieval monk illustrating Bibles or prayer books. However, Alberto Sangorski (1862–1932), hand-lettered and illuminated copies of Abraham Lincoln's Gettysburg Address and Second Inaugural Address as well as Walt Whitman's poem "O Captain! My Captain!" in London about 1929. The pages were ornately custom-bound by the British firm Riviere and Sons and exhibited at the Kroch's Bookstore booth at the Century of Progress exposition in Chicago (1933–1934).

On July 12, 1933, just after they received the book, N. F. Guess of Kroch's Bookstore wrote to the avid Lincoln collector and Illinois governor Henry Horner, describing the book and urging Horner to see it at the exhibit. Guess listed its price as $2,500, a substantial sum in 1933. After the exhibit ended, a group of nineteen of Horner's friends (including

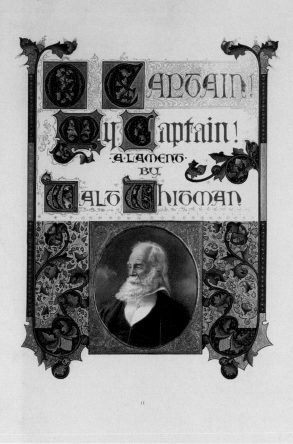

First page of "O Captain! My Captain!" in Sangorski-illuminated volume

Adolph Kroch) purchased the book and presented it to him at a dinner on January 2, 1935. Although much of Henry Horner's Lincoln collection came to the Library in 1940, Henry H. Straus, Horner's nephew, presented this exceptional piece to the Library in 1952.

While all of the pages in the volume are ornamented to some degree, the Whitman poem is more thoroughly illuminated than either of Lincoln's speeches.

O Captain! My Captain!
BY WALT WHITMAN

O Captain! My Captain! our fearful trip is done;
The ship has weathered every wrack, the prize we
 sought is won;
The port is near, the bells I hear, the people all
 exulting,
While follow eyes the steady keel, the vessel grim and
 daring:
But O heart! heart! heart!
O the bleeding drops of red,
Where on the deck my Captain lies,
Fallen cold and dead.

O Captain! my Captain! rise up and hear the bells;
Rise up—for you the flag is flung, for you the bugle
 trills;
For you bouquets and ribboned wreaths, for you the
 shores a-crowding;
For you they call, the swaying mass, their eager faces
 turning;
Here Captain! dear father!
This arm beneath your head;
It is some dream that on the deck
You've fallen cold and dead.

My Captain does not answer, his lips are pale and
 still;
My father does not feel my arm, he has no pulse nor
 will;
The ship is anchored safe and sound, its voyage closed
 and done;
From fearful trip the victor ship come in with object
 won;
Exult, O shores! and ring, O bells!
But I, with mournful tread,
Walk the deck my Captain lies
Fallen cold and dead.

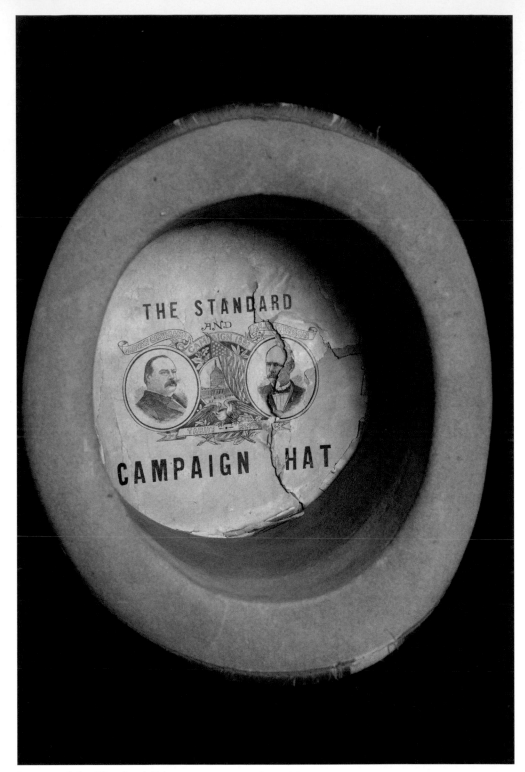

Interior of the Cleveland-Stevenson campaign hat, 1892

10. *Unusual Items*

Adlai Ewing Stevenson I (1835–1914), grandfather of the Illinois governor and two-time Democratic presidential candidate of the same name, was a Bloomington, Illinois, lawyer and politician. He served in Congress (1875–1877, 1879–1881) and as first assistant postmaster general (1885–1889) before his nomination as vice president in 1892 during Grover Cleveland's third campaign for the presidency. While Cleveland campaigned from his front porch, Stevenson traveled widely around the country, an effort that was fairly unusual for that era. Even more unusual, Stevenson's wife, Leticia, campaigned with him part of the time. The Cleveland-Stevenson ticket was elected, allowing Stevenson to serve as vice president during Cleveland's second term (1893–1897). Cleveland is the only U.S. president elected to two nonsuccessive terms.

This gray top hat, probably used by one of the Democratic political clubs, was donated to the Library by Adlai Stevenson III in 2012.

Hat from the 1892 Democratic presidential campaign of Grover Cleveland–Adlai Stevenson I (6″ high × 9″ wide × 11″ deep)

Abraham Lincoln's note to Captain John A. Dahlgren, October 14, 1862
(1⁷/₈″ high × 3¹/₈″ wide)

"Capt. Dahlgren may let 'Tad' have a little gun that he cannot hurt himself with. A. Lincoln Oct. 14, 1862"

Abraham Lincoln's note was addressed to his friend Captain John A. Dahlgren (1809–1870), commander of the Washington Navy Yard, where Lincoln often went to see weapons tested. Dahlgren obliged with this working model of a 12-pounder boat howitzer that he himself had recently invented. Before giving the cannon to Tad, however, Dahlgren bent the firing pin so that the model could not be used.

The cannon and note were purchased in November 1941.

Tad Lincoln's model cannon (5¾″ high × 5¾″ wide × 12¾″ deep)

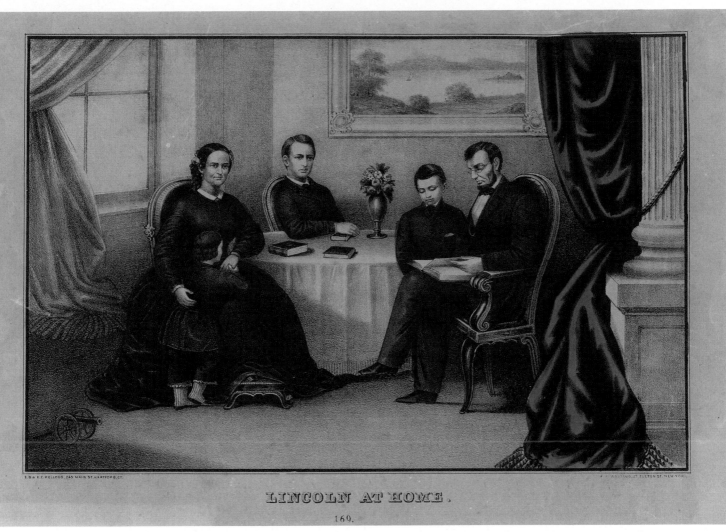

LINCOLN AT HOME.

169.

"Lincoln at Home," composite family grouping from real and imagined images, including Tad's cannon, by E. B. and
E. C. Kellogg (Hartford, Connecticut, 1864?) (12″ high × 16″ wide)

The Library's twenty-one accessions books are truly hidden treasures. They were used to record acquisitions information until January 17, 1977 when, after recording item number 125626, the Library switched to accessions cards (which are still in use). Although few people beyond the Library staff know about or have seen these record books, they provide valuable information on the provenance (source) of all types of Library materials.

Accessions book no. 15, March 16, 1947–November 22, 1954 (13½" high × 25" wide)

One of the items, accessioned as number 88461, is an original printing of Josiah Henson's *The Life of Josiah Henson, Formerly a Slave* (1849), one of the models Harriet Beecher Stowe used when she wrote *Uncle Tom's Cabin*. Henson's book was accessioned in July 1948 after being purchased for $5 from Lawrence B. Romaine, a Massachusetts manuscripts and rare-book dealer, who also collected and wrote about trade catalogs from various businesses.

The Life of Josiah Henson, Formerly a Slave, 1849

Illinois State **Education** Society: dir mtg, Je25/41-3:2; mtgs, Ja7/47-3:5,
 Mr18-2:7, **Ja13**/48-2:7; *Ja16/49-3:1, *Ja23-3:1; eds asked to give pub-
 licity to, Ap29/47-2:2; circular, My13-1:4

Illinois State Gazette & Jacksonville News: prospectus, F8/34-3:6; discon-
 tinued, Ag16-3:6; reestb, S6-3:4; **1st no recd**, S13-3:1; proposes intl
 impr conv - discussed in edl, Ag27/36-2:1; **Jnl** ridicules ed of, N4/37-
 2:2; denounces US Bk, D23-2:2

Illinois State Hospital **for** the Insane: estb by leg, F25/47-2:3-5, (text)
 Ap8-1:6-7; bids **for** constr asked, D9-3:2

Illinois State House: **see** Illinois Capitol Building

Illinois State Legislature: **see** Illinois General Assembly

Illinois State Library: leg act in relation to, Ja21/47-2:2

Illinois State Lottery: authorized by leg - list of prizes, F2/39-3:5

Illinois State Lyceum: org, D22/31-3:3; mtgs, Jy12/32-3:2, Jy13/33-3:3,
 Ag31-3:4, Ag16/34-3:6, Ag1/35-3:4

Illinois State Medical Society: Spfd mtgs, D24/46-3:5, Je5/50-3:1

Illinois State Musical Society: org, O4/34-3:1; reorg, Ag20/41-2:3; Spfd
 mtg, Ap1/42-3:3; annual mtgs, Ag26-3:3, Mr30/43-3:3

Illinois State Register [Vandalia-Springfield]: pub semi-weekly during leg
 session, N8/34-3:1; comments on R M Whitney & Ill St Bk, Ap9/36-2:2;
 discussed in edl, Ag27-2:1; calls on Jackson men to join VBuren Pty,
 O15-2:3; arts on intl impr, F11/37-2:6, F10/38-2:2; opposes St Bk &
 intl impr, Mr25/37-3:1-2; tries to keep capital at Vand, Jy1-1:5-6,
 -2:4; comments on bkg situation, F2/38-2:3; comments on bldg of capi-
 tol, Mr17-2:3, Mr31-2:2; praises Sidney Breese, Ap28-2:3; misrepresents
 Whig-Conservative barbecue, O13-2:3; moves to Spfd from Vand, Jy5/39-
 2:6; merges w **Ill Repub**, Jy12-2:4; quotes parts of documents out of con-
 text for polit effect, O11-1:7; attacks John Tillson jr, Ja28/40-2:1;
 attacks W Ross, Mr6-2:3; opposes Constn Conv, F19/41-2:1; opposes John
 T Stuart, Ap30-2:1; attacks Zadoc Casey, My14-2:1; fined $100 in Garn-
 sey's libel suit agst, N26-2:7;
 attacks Silas Reed, Ap1/42-2:7; favors taxing Ill land as soon as
 entered, Ap29-2:2; attacks Jos Duncan, Je3-2:3; suggests Ford for gov,
 -2:5; Ford crit veracity of, Jy22-3:2; denounced by **People's Advoc**, S23-
 2:4; attacks A W Cavarly, Ja12/43-3:1; disputes w **Spfd Times**, Ja4/44-2:5
 ff; attacks J J Hardin, Ja25-2:2; accuses Whigs of spiking cannon, Ag1-
 2:5; chgs Hardin is hostile to Amer mfrs, -3:2; comments on Stephen T
 Logan, Ja2/45-3:2; attitude toward Mormons, My8-2:1, My29-2:2, -2:5,
 Je12-2:7; crusades agst Ill Cong deleg, Je26-2:1; tries to make St Bk
 princ issue Constn Conv, Ap8/47-2:1; tries to keep **Jnl** from pub oftener
 than once a week, Je22/48-2:4; pub **Ticket**, Jy13-3:4; misquotes Walter
 Davis, O3-2:3-4; calls Wentworth demagogue, D6-3:1; supports Wentworth
 for US sen, *My4/49-2:1; eds of in str fight w **Jnl** eds, *Je16-3:1; see
 also **Illinois Advocate**; **Illinois Republican**; **Ticket**

Illinois State Silk Society: org mtg, constn & officers, S20/39-1:7; mtg,
 S27-2:6

Illinois State Temperance Society: org, D22/31-3:3; pub **Temp Visitor**, Ja19/33-
 3:4; books destroyed by Alton fire, O11/39-2:4; mtgs, **Ja1**/46-4:1, D24-3:5;
 calls st conv, -3:5; memorial to leg, Ja28/47-2:2; **see also** Washington
 State Temperance Society

Illinois Statesman [Paris]: accuses **Jnl** of unfairness to Douglas, Mr10/38-2:2;
 Statesman's motives questioned by **Jnl**, Ap21-2:1

Illinois Sunday School Banner [Rock Spring]: prospectus, My17/32-3:2; 1st no
 recd, -2:5; discussed in edl, Ag27/36-2:1

Illinois Sunday School Union: Vand mtg, D22/31-3:3; pub **Ill SS Banner**, My17/32-
 3:2; books destroyed in Alton fire, O11/39-2:4

Illinois Supreme Court: **see** Supreme Court of Illinois

Illinois Telegraph Company: officers elec, N21/49-3:4; **cf** Illinois & Missis-
 sippi Telegraph Company

Illinois Temperance Herald [Alton]: pub defamatory art on Island Grove citz,
 Ap12/39-2:4

Index to Illinois Items in the Springfield "Journal," compiled by James N. Adams, 1944–46 (14¹⁄₂″ high × 11″ wide)

Other staff members besides Jessie Palmer Weber have produced treasures that are important for their usefulness to staff and patrons. One of these is the *Index to Illinois Items in the Springfield "Journal"* (1831–1860), a newspaper known successively during those years as the *Sangamon Journal*, the *Sangamo Journal*, and the *Illinois Journal*. This typed, two-volume in-house index was prepared on onion-skin paper by then-newspaper librarian James N. Adams (1911–1965), between 1944 and 1946. For decades it has assisted researchers seeking information on Springfield and recently was digitized and added to the Illinois Historic Preservation Agency's website.

Adams was himself a type of treasure. During his more than twenty-year tenure at the Library he also prepared the published indexes for the *Collected Works of Abraham Lincoln*, edited by Roy P. Basler; the *Transactions of the Illinois State Historical Society*; and the first fifty volumes of the *Journal of the Illinois State Historical Society*. He also compiled the first edition of *Illinois Place Names*. There is no known photo of Adams.

Robert Todd Lincoln, the oldest son of Abraham and Mary Lincoln and their only child who survived to adulthood, married Mary Harlan of Mount Pleasant, Iowa, in 1868. Their younger daughter, Jessie, became friends with Susan Roper when the Lincoln children visited their Harlan grandparents in Iowa. Susan sometimes came to visit Jessie in Chicago, and on one occasion Jessie gave her the dinner bell as well as some family photographs. The bell remained in Susan's family until early 2012, when a descendant sold the bell to the Library.

Surviving Lincoln family artifacts that make noise are very rare. Steven Spielberg used Robert's dinner bell in a scene in the movie *Lincoln* (2012) when Mary Lincoln delayed a White House receiving line to lecture Congressman Thaddeus Stevens.

Dinner bell that belonged to Robert Lincoln (6¼″ high, 3¾″ base diameter)

Key to Paul Powell's hotel suite, 1970 (key: 2″ long × 1⅛″ wide; plastic tag: 3½″ long × 1¾″ wide; metal tag: 4″ long × 2″ wide)

Paul Powell

Paul Powell (1902–1970), Illinois secretary of state (1965–1970), and Democratic wheeler and dealer, served in the state legislature from 1935 to 1965 with several terms as speaker of the house. Powell was also involved in promoting horse racing. Although Powell maintained a residence in his hometown of Vienna, Illinois, he generally lived in apartment 546 at the St. Nicholas Hotel in Springfield. After his unexpected death on October 10, 1970, some $800,000 in cash was found in a shoebox and other containers in Powell's apartment closet. The sources of the money were never entirely clear.

The Library received the apartment key in 2010.

In 1949 the Illinois state legislature passed a bill requiring owners to keep cats on a leash in order to protect birds. Illinois governor Adlai E. Stevenson II (1900–1965) vetoed the bill with a humorous message. While the original veto is in the Illinois State Archives, decorated versions like this one sold for $5 at the fundraising fair of the Unitarian church in Bloomington, Illinois, where Stevenson was a member. This copy was among the papers given to the Library by Stevenson's sister, Elizabeth Stevenson Ives.

Governor Adlai Stevenson II

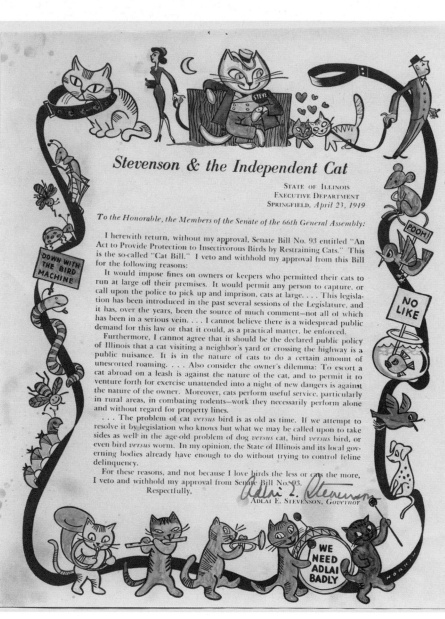

Ornamented version of Governor Adlai Stevenson's "cat veto," 1949 (10¹/₁₆″ high × 8¹/₈″ wide)

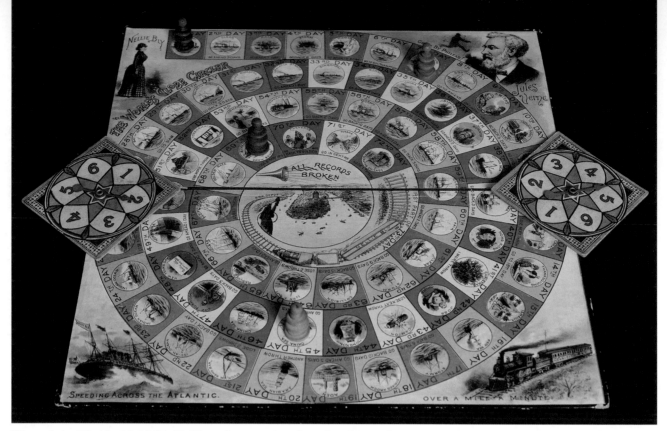

"Round the World with Nellie Bly" board game, 1890 (board: 16" square)

Nellie Bly (1864–1922) was a reporter for the New York *World*. On November 14, 1889 (about the same time as the Library was being organized), Bly left New Jersey by steamer for England. Traveling unaccompanied and speaking no language but English, Bly was making a much-publicized attempt to beat the imagined round-the-world travel record of eighty days set by Phileas Fogg, hero of Jules Verne's 1873 novel. Bly arrived back in New Jersey on January 25, 1890, seventy-two days after she had left.

Bly's exciting adventure was quickly shared with others in this colorful board game, "Round the World with Nellie Bly," produced in 1890 by McLoughlin Brothers. It was apparently the most successful of numerous marketing ventures that took advantage of Bly's fame. The Library's copy is still complete with board, directions, spinner, and markers. The game is played by moving along a spiral route the number of days of Bly's adventure as determined by the spinner.

The Nellie Bly game is one of the most visually interesting of the more than fifty historic children's games, dating from the 1840s through the 1920s, in the Library's collection.

Judy Baar Topinka, by profession a journalist in the Chicago area, has held a number of political posts, including state representative (1981–1985), state senator (1985–1995), and state treasurer (1995–2007). After her defeat as the Republican candidate for governor in 2006, she was elected state comptroller, a post she assumed in 2011.

As a delegate to four Republican National Conventions, 1992 (Houston), 1996 (San Diego), 2000 (Philadelphia), and 2004 (New York), Topinka gathered "paddles," or signs, originally on top of poles and used to locate the Illinois delegation. For the last three conventions she also collected the signatures of the Illinois delegates on those paddles, an unusual convention souvenir. In 2004, the year shown, Topinka was the chairperson of the Illinois delegation that helped to renominate George W. Bush. She donated these paddles to the Library in 2005.

"Paddle" marking the place of the Illinois delegation to the Republican National Convention in New York, 2004 (44″ high × 10″ wide, each triangular side)

Lincoln's stovepipe hat

Perhaps no other object is so identified with an American president as Abraham Lincoln's stovepipe hat. This style of hat became popular among rising middle-class Victorian men in England in the 1830s and spread to America. Although Lincoln was certainly not fashion conscious, he nevertheless adopted the stovepipe hat. The style proved convenient for Lincoln in other ways since he used the inside of his hat as a file for papers, especially when he was out on the legal circuit.

No one knows exactly when Lincoln began to wear stovepipe hats or how many he owned. However, two other hats besides this one are known to exist—one at the Smithsonian and one at Hildene, Robert Todd Lincoln's home in Vermont. The Library's treasure was made in Springfield of felted beaver fur by Josiah H. Adams, who began his business in the town in 1844. If Lincoln bought the hat in the mid-1850s, as is believed, he paid about $4 for it. The hat came to the Library in 2007 as part of the Louise and Barry Taper collection.

Afterword

Working on this project has been the highlight of my twenty-third year at the Library. When I came to the Library from the Illinois State Library Reference Department, where I had been Division Head, I was excited and eager to begin learning another specialized area of librarianship—American history and, more specifically, Illinois history with a dash of Lincoln history tossed in for good measure. Having been intimately involved in the many activities that have occurred at the Library over the years, I am honored to be able to share my thoughts in this essay.

Those who preceded me as Library Directors, Directors of Research, State Historians, and Head–Library Division left big shoes for me to fill, and I have worked to leave a legacy much as they did during their tenures. They moved the Library collections, oversaw and managed new building construction projects, and enriched and strengthened already strong Illinois historical and Lincoln collections. I owe much to those who came before, and I thank, admire, and appreciate their efforts.

At the Abraham Lincoln Presidential Library and Museum, incorporating the Illinois State Historical Library, I have had the honor and pleasure of working with a dedicated and knowledgeable staff who not only provide quality service to our library patrons and visitors but also have taught me a great deal about history, scholarship, respect, and leadership. I owe them much.

No two days at the Library are ever the same, as every visitor and patron is unique and has a unique information need. Over the years, the Library and its staff have moved from one Capitol building to another and finally to the beautiful facility where we live today. I have seen the progression from a card catalog to an online bibliographic utility; from researching reference questions in paper indexes to researching in online databases; from drafting replies on a typewriter—and, oh my, the "whiteout" and correcting ribbons—to using Wangs and Word documents. The ride has been a thrilling

and challenging one for me and I hope also for the staff. It is my hope that the next 125 years will provide an equal level of enthusiasm and service as the previous ones have.

Finally, I extend my sincere thanks to our Agency and Library and Museum leadership and to the compiler of this treasure, Glenna Schroeder-Lein; to all of the staff who worked diligently to select the treasures and write about them; to those at SIU Press for their guidance, leadership, support, and patience; and, finally, to Patrick Russell for his photographic skills.

Happy 125th to the Library, and may there be many more to follow!

Kathryn M. Harris
Director, Abraham Lincoln Presidential Library

Acknowledgments

This book could not have been prepared without the valiant assistance of Kathryn Harris, whose encouragement and support throughout the process was indispensible. Patrick Russell took the photos, prepared the scans, and sent the images to the Press. He graciously worked with whatever quirky material we presented to him. Gwen Podeschi, model reference librarian, found the big and little details I needed. Cheryl Schnirring also provided vital research and support assistance.

I am thankful for additional assistance provided by Bryon Andreasen, James Cornelius, Jennifer Ericson, Mary Ann Pohl, Debbie Hamm, Jan Perone, Mary Michals, Roberta Fairburn, Gary Stockton, Chris Lush, Jane Ehrenhart, Tom Schwartz, Amy Martin, Eileen Mackevich, Caitlin Crane, Jess Hagemann, David Littlefield, Jack Navins, and one person who does not wish to be publicly acknowledged.

Special thanks to all the people who contributed comments about their Library experiences. And an extra special thanks to Sylvia Frank Rodrigue and Barb Martin of Southern Illinois University Press, who have been enthusiastic, encouraging, patient, and helpful throughout the process.

Glenna R. Schroeder-Lein

Staff of the Abraham Lincoln Presidential Library (*left to right*): *row 1*, Jane Schmidt, Chris Lush; *row 2*, Cheryl Schnirring, Kathryn Harris, Jennifer Ericson, Doug Watson, Eileen Mackevich, Mary Michals, Roberta Fairburn, Mark DePue; *row 3*, Debbie Hamm, Amanda Helm, Gwen Podeschi, Jenny Sawyer, Daniel Stowell, Christian McWhirter, Jan Perone, Boyd Murphree; *row 4*, Connie Butts, David Littlefield, Jess Hagemann, Teri Barnett, Jane Ehrenhart, James Cornelius, Mary Ann Pohl, Jerry Jensen, Glenna Schroeder-Lein, Bob Cavanagh

Staff Lists

Library Staff as of June 1, 2013

Kathryn Harris, Director

Teri Barnett, Microfilming Lab
Connie Butts, Cataloging
Bob Cavanagh, Interlibrary Loan
James Cornelius, Lincoln
Mark DePue, Oral History
Jane Ehrenhart, Printed and Published
Jennifer Ericson, Lincoln
Roberta Fairburn, Audio Visual
Jess Hagemann, Artifacts
Debbie Hamm, Manuscripts
Amanda Helm, Microfilming Lab
Jerry Jensen, Security
Christine Lush, Secretary
Christian McWhirter, Digital Initiatives
Mary Michals, Audio Visual
Boyd Murphree, Digital Initiatives
Bonnie Parr, Conservation Lab
Jan Perone, Newspapers
Gwen Podeschi, Printed and Published
Mary Ann Pohl, Lincoln
Debbie Ross, Interlibrary Loan
Jenny Sawyer, Printed and Published
Jane Schmidt, Cataloging
Cheryl Schnirring, Manuscripts

Glenna Schroeder-Lein, Manuscripts
Gary Stockton, Acquisitions
Daniel Stowell, Digital Initiatives
Doug Watson, Microfilming Lab

Head of Illinois State Historical Library/ Abraham Lincoln Presidential Library

(Librarian, State Historian, Director of Research, Head–Library Division, or Library Director as titles varied)

Josephine P. Cleveland (1889–1897)
Jessie Palmer Weber (1898–1926)
Georgia L. Osborne (1926–1932)
Paul M. Angle (1932–1945)
Jay (James) Monaghan (1946–1950)
Harry E. Pratt (1950–1956)
Clyde C. Walton (1956–1967)
William K. Alderfer (1967–1981)
Olive S. Foster (1981–1985)
Roger Bridges (1985–1987)
Janice Petterchak (1987–1995)
Kathryn M. Harris (1996–)

State Historians

Paul M. Angle (1943–1945)
Jay (James) Monaghan (1946–1950)
Harry E. Pratt (1950–1956)
Clyde C. Walton (1956–1967)
William K. Alderfer (1967–1981)
Olive S. Foster (1981–1985)
Michael J. Devine (1985–1991)
E. Duane Elbert (1991–1993)
Thomas F. Schwartz (1993–2011)

Lincoln Curators

James T. Hickey (1958–1984)
Thomas F. Schwartz (1985–1993)
Kim Matthew Bauer (1994–2006)
James M. Cornelius (2007–)

Abraham Lincoln Presidential Library and Museum Directors

Richard Norton Smith (2003–2006)
Rick Beard (2006–2008)
Eileen R. Mackevich (2010–)

Illinois Historic Preservation Agency Directors

David Kenney (1985)
Michael J. Devine (1985–1990)
Susan Mogerman (1990–2002)
Maynard Crossland (2002–2004)
Robert Coomer (2004–2008)
Jan Grimes (2008–2011)
Amy Martin (2012–)

Index

Page numbers in bold type represent illustrations.

Glenna R. Schroeder-Lein has been a manuscripts librarian at the Abraham Lincoln Presidential Library since 2005. She is the author of numerous articles and book reviews as well as four books, including *Lincoln and Medicine* (2012).

An Illinois original

Treasures of the Abraham Lincoln Presidential Library
is an Illinois original.

Conceived of, gathered, written, and edited by the Abraham
Lincoln Presidential Library in Springfield, Illinois.
Copyedited, designed, and typeset by Southern Illinois
University Press, Carbondale, Illinois.
Printed and bound by Versa Press, East Peoria, Illinois.
Distributed by Chicago Distribution Center, Chicago, Illinois.

Composed in Adobe Garamond Pro
Printed on 70# gloss-coated paper
Hardback edition bound in Arrestox B with Vellum finish

The cover for the paperback edition and the jacket for the hardback
edition were printed in four-color process and include gloss and dull
varnish, foil stamping, and embossing, all provided by Versa Press.

————————◆————————